Representing Youth with Disability on Television

CRITICAL ISSUES FOR LEARNING AND TEACHING

Shirley R. Steinberg
Series Editor

Vol. 23

The Critical Qualitative Research series is part of the Peter Lang Education list.
Every volume is peer reviewed and meets
the highest quality standards for content and production.

PETER LANG
New York • Bern • Frankfurt • Berlin
Brussels • Vienna • Oxford • Warsaw

Dana Hasson

Representing Youth with Disability on Television

Glee, Breaking Bad and *Parenthood*

PETER LANG
New York • Bern • Frankfurt • Berlin
Brussels • Vienna • Oxford • Warsaw

Library of Congress Cataloging-in-Publication Data
Names: Hasson, Dana, author.
Title: Representing youth with disability on television:
Glee, *Breaking Bad* and *Parenthood* / Dana Hasson.
Description: New York: Peter Lang, 2016
Series: Critical qualitative research; vol. 23
ISSN 1947-5993
Includes bibliographical references.
Identifiers: LCCN 2015047352 | ISBN 978-1-4331-3251-3 (hardcover: alk. paper)
ISBN 978-1-4331-3250-6 (paperback: alk. paper) | ISBN 978-1-4539-1811-1 (e-book)
Subjects: LCSH: People with disabilities on television.
Youth with disabilities. | Youth on television. | Sociology of disability.
People with disabilities in mass media.
Classification: LCC PN1992.8.H36 H37 2016 | DDC 791.45/6527—dc23
LC record available at http://lccn.loc.gov/2015047352

Bibliographic information published by **Die Deutsche Nationalbibliothek.**
Die Deutsche Nationalbibliothek lists this publication in the "Deutsche
Nationalbibliografie"; detailed bibliographic data are available
on the Internet at http://dnb.d-nb.de/.

Cover image: ©Shutterstock/Pongmanat Tasiri

The paper in this book meets the guidelines for permanence and durability
of the Committee on Production Guidelines for Book Longevity
of the Council of Library Resources.

This book is dedicated to my New York and Montreal families, Sam, Liam and Ella and to anyone ever called different, unique, atypical or weird you are the innovators, inspiration and creative forces that will continue to drive us forward. Thank you for who you are.

Table of Contents

Acknowledgments ix

Chapter 1. The Personal Is the Public: My Story 1

Chapter 2. Mapping Out Disability 29

Chapter 3. What Do Popular Culture, Television, and
 Youth Have to Do with It? 47

Chapter 4. Youth Is Wasted on the Young and Other
 Myths About Popular Culture 59

Chapter 5. A Methodology to the Madness 69

Chapter 6. Game of Themes 79

Chapter 7. "Breaking" Down the Content 103

Chapter 8. (Dis/Dys)abling the Truth: Findings and
 Implications for Pedagogy 113

Chapter 9. Series Finale: Changing Attitudes and
 Perceptions Through the Media 127

Notes 133

References 135

Acknowledgments

The function of education is to teach one to think intensively and to think critically. Intelligence plus character—that is the goal of true education.

— Martin Luther King, Jr. —

This book would not have been possible without the love, support, and encouragement I received from my husband Sam, my children Liam and Ella, my parents Jack and Randi, my second parents Marcel and Soly, my brothers Jeremy and Cory, Julie, Shane David, Nancy, Kayla, Dylan, and friends (you know who you are). It also is crucial for me to recognize my late grandparents Leon, Eva, Ike, and Mollie; they were instrumental in my development and have inspired me in more ways than I thought possible. My grandmother Eva will never know how much she turned my life around as I watched her face challenges and push through adversity (surviving the Holocaust and living through an amputation) to prove to herself and her family that she would not be beaten down but lifted up. My grandfather Leon, a Holocaust survivor as well, always expressed his wish for his grandchildren to pursue education and take it as far as it could possibly go. As a man who never

had that opportunity because of his circumstances, it was his biggest dream, and I hope that I have fulfilled his wish and have made him proud. My grandparents Ike and Mollie always only saw the best in their grandchildren and fed us with kindness and unconditional love that transformed into our realization of what it means to treat people with kindness, respect, and the purest form of love. Only now am I beginning to realize how much my family has sacrificed so that I could reach for the stars and push through what has been a challenging, yet incredibly rewarding time in my academic/personal life. I do not have words to adequately describe my deep gratitude for all they have provided me, although I hope to show them in the years to come. I have benefited greatly from the mentoring of Dr. Shirley Steinberg, Dr. Steve Jordan, and Dr. Karen Gazieth—their comments and exceptional efforts to make my work the best it can be will always be treasured and appreciated. Dr. Steinberg was instrumental in helping me to carry out a study relating to critical disability and pedagogy as I reflected on my past experiences and interests in both media studies and disability studies. I developed a tremendous desire to learn and understand this multifaceted topic of study. I am truly indebted to her for fostering the same pursuit and fascination in me and, of course, for her assistance and advice during my years as her student. Dr. Jordan has been a patient, helpful guide who never gave up on my efforts. It has taken many years and a lot of patience and persistence to bring this research to fruition. In essence, I hope that this book will make an impact in the field of critical disability and media studies. I hope that it will open the door for further exploration and understanding of a topic that has been marginalized for so long. I am hopeful that we are living in a time where diversity and acceptance is the norm and people are seen as people not objects, with varying strengths and abilities.

The Personal Is the Public: My Story

> Stereotype assumptions about people with impairments are based on super-stition, myths and beliefs from earlier less enlightened times. They are inher-ent to our culture and persist partly because they are constantly reproduced through the communications media; books, films, television, newspapers and advertising. (Barnes, 1991, p. 45)

Who am I? How do I situate myself in my writing and what life expe-riences have brought me to this point in life? What effect do I want my work to have in my field and beyond? In *Qualitative Inquiry*, Butler-Kisber (2010) asks, "Who we are as researchers, our research identities, changes with time and experience, just as our everyday identities do" (p. 19). I believe that our experiences, especially early in life, mold us into the individuals we will become and give us a strong foundation for what will turn our passion into substance. Who I am affects my re-search, and I consider my positionality as I introduce this work.

Delving deeper into the reasons I have devoted so much time and energy to this field will become apparent as I weave together my past to make sense of my present. As a point of entry, I use the opening quote about stereotypes and myths about disability from Barnes (1991).

I believe that this quote represents my burning desire to research a topic that falls under the radar so frequently, yet is fundamental to understand because of the impact it has on those who often are denied a voice in which to express their truth.

In developing the research question for this topic, I had to observe, reflect, and ask questions of the questions already posed and stay true to myself in the process. The overarching question that evolved from this process is the following: How can my research on popular culture be contextualized within the theoretical literature on critical disability studies in education? *Critical disability studies in education* can be defined as a critical investigation of disability through a sociopolitical lens that applies humanities, social sciences, and art-based methodologies to on-going matters related to education and pedagogy (Gabel, 2005/2009).

As Kincheloe (2005a) states, "all observations of the world are shaped either consciously or unconsciously by social theory" (p. 324). Using a theoretical framework in research helps explain the relationship between our observations of the world and their effect on our daily lives. An approach grounded in cultural studies supports an exploration of the various concepts and methodologies responsible for constructing our views regarding the politics of media and representation.

Media culture is the dominant form of culture that socializes us in terms of our identity, social reproduction, and change. Cultural studies is especially useful for this type of research because it provides a specialized understanding of marginalized groups with respect to race, class, gender, and ability. It is my intention to link theories from media, education, and cultural studies because these three disciplines seek to understand the production of all things related to culture. While looking at the different aspects of culture and media, my personal narrative emerged, and parts of my past began to unravel and created a need to understand how I got to where I am and why I chose to use particular concepts and theories for this study. I have outlined the steps I took to identify my position as a researcher and express my passion for both disability and media studies in popular culture in a manner that reflects my process (Hall, 1992; Kellner, 1995).

I will begin with a discussion about my unexpected encounter with disability and how this inspired me to question who I am, and in turn

how it introduced me to a new world with which I had yet to become familiar. Then I move on to my early experiences with television, influenced to a great extent by my grandparents and the family dynamic created around this powerful technology. I tell the story of my grandparents, who survived the Holocaust, and their persistence to maintain normalcy through the atrocities they suffered. I briefly talk about my experience working in the media field in New York City and how an anecdote from my father—about a teacher and his connection with a marginalized, powerless student—caused me to shift careers and interests. I discuss my experience working in a special needs classroom with students who had severe learning differences. Finally, I introduce some of the theories that have informed my work in the areas of disability and media studies, which I expand on in later chapters that discuss methodology.

Poignancy: My Encounter with Disability

The shedding of the illusion of identity allows for our "lived experience" to come to the forefront. Thus our "lived experience" would be an integral part of the atmosphere and tone for any change within our lives and our interaction with others, whether they be disabled or non-disabled. (Overboe, 1999)

My relationship with disability differs from those individuals who actually live daily with a physical or mental disability. As an able-bodied person, I am using a unique lens to look at the disabled population. As I became interested in this particular area of research, I delved into my childhood to connect the personal with the academic.

When I decided to pursue a study involving disability, I thought it would be important to include my early memories of disability and how I interpreted differences at a young age. I recall with great trepidation being in a public space (e.g., mall, movie theater, department store) and my initial reactions to an individual missing an arm, a leg, part of his or her face, or those individuals walking with a large group and needing an aide because of what I later learned from my mother was a mental deficiency called Down syndrome. I remember being extremely

uncomfortable when I came into contact with disability. I suppose the awkwardness I felt had more to do with an infantile ignorance and the social division between those who are able-bodied and those who are not, as well as a child's discomfort with someone who looked different. As I grappled with my past experiences with disability, one of the first theorists to inform my work on the body was Leder (1990), who characterized the body as having two dimensions—*lieb* (lived experience) and *korper* (categorization). In an attempt to understand one's everyday perception of the living body, it is critical to look at what characteristics he or she picks up on when face to face with another human being. The ability or inability to sift out the characteristics that stand out in an individual, in large part, plays a role in how a person living with disability forms his or her identity. Merleau-Ponty (1962/2005), another theorist who discusses the body and consciousness, ties these phenomena together by arguing that the "lived body" does not differ from consciousness. He states, "We make perception out of things perceived. And since perceived things themselves are obviously accessible only through perception, we end by understanding neither" (p. 4). Merleau-Ponty's theory of embodied perception is examined by Abram (1996) in *The Spell of the Sensuous: Perception and Language in a More-Than-Human World*. Abram points out that perception is reciprocal—the body perceives the world and the world perceives it. The body perceives the world through the senses and grows out of and remains continuous with the environment, experiencing and perceiving meaning by other ways of knowing (especially through the senses, which Abram argues are the doorway to our imagination) that go beyond simply our thoughts about the world.

Both Merleau-Ponty (1962/2005) and Leder (1990) argued that knowing ourselves through the mind and the body assists in identity formation and creates a way of life that allows for a more grounded place in the world. This identity formation also occurs as we make social connections, and similarities and differences both physical and emotional begin to emerge. As I look more closely at identity, I discuss my grandmother and her experiences as a Holocaust survivor and a woman who would later have her leg amputated due to complications with diabetes. These experiences have worked to influence my

own ideologies and have caused me to reevaluate notions of the "lived body." Discussing the "lived body" within this particular research relates to the relationship between the physical body of youth living with disability and how this is interpreted by society.

My grandmother, Eva, identified herself as an Eastern European Jew who survived the Holocaust. Her intense experience began when she was 12 while waiting in a line at a concentration camp in Poland with her entire family of seven. Suddenly, she was yanked out of the line by a Polish police officer who asked why she was in line with the Jews "when she looked so much like a Polack" (luckily for my grandmother, she was blonde-haired and blue-eyed, the quintessential Aryan child). My grandmother's mother heard this and told her to get out of the line and to take her nine-year-old brother Stanley with her. My grandmother immediately ran away as fast as her thin legs could carry her, and her little brother did his best to keep up with her. For the next five years, the two of them went into hiding, begging for jobs and a place to sleep. The intensity of my grandmother's "lived experience" during her teenage years on the run with her brother in survival mode speaks volumes about her strength and resourcefulness at such a young age. She used her two legs to run through the streets of Poland, to do what was necessary to take care of herself and her baby brother. The irony of what was to come later in her life has played a considerable part in why I have become interested in the field of disability.

When my grandmother was 16, the Jewish people were liberated, and she was free to live her life as a Jew with her brother. My grandmother met my grandfather, Leon, also a concentration camp survivor, almost immediately after the war, and they had one of the first religious weddings in 1945.

When my grandmother was in her late 40s, she was diagnosed with type 2 diabetes. She never found the appropriate way to care for herself or to live cautiously with her disease: she saw it as more of an unnecessary burden than as a serious condition that necessitated that she take better care of herself to manage it properly. It was difficult for her to accept what she had, and it overwhelmed her sensibility. In essence, my grandmother was held captive by this disease, and in an ironic turn of events, her will to survive turned to capitulation. It was as if she had

surrendered all of the strength and determination that had served her well in all her days in hiding, and she had no more willpower to go on with diabetes. The depth of her surrender became clearer to me five years later when she developed gangrene, a life-threatening condition that arises when a body part loses blood supply. Her condition became so unmanageable that the doctors had to amputate part of her right leg, which put her and our family in a position we could never have imagined. Questions about how we would go on with her as a disabled woman began to surface, and we realized how much we needed to learn and accept about her new "identity." The concept of the disabled body "dys-appearing" because of a dysfunction (Leder, 1990) can cause individuals to focus on the part(s) of the body that are missing and make all other characteristics disappear, thus focusing mainly on the impairment (i.e., loss of leg). I begin with this recollection because I believe it is more powerful to start with the impact that disability can have on a lived life and *then* juxtapose this against the impact of representations of disability on TV.

Barnes and Mercer (2003) discuss Young's (1990) concept of *cultural imperialism* as a devaluation or undermining of a particular group by dominant and negative social stereotypes, which magnify the notion of that group as the "Other." In some sense, this concept helps to explain why my mother, especially, internalized the pain and suffering that my grandmother was going through and felt this amputation had marked the end of my grandmother's life as my grandmother knew it. The thought of my grandmother being categorized as the "Other" and marginalized by society was difficult for both my mother and my grandmother to grasp. However, that all changed when my grandmother entered a rehabilitation center in upstate New York and was surrounded by other individuals in similar circumstances, who carried a more positive, optimistic view about what had happened to them and had realized, as a group, that they were not necessarily the "Other"— rather, they were the other minded. The experiences of the people my grandmother met at the rehab center opened her eyes to a greater awareness of differences and demonstrated a deep desire, at physical and psychological levels, to gain back mobility and strength.

In the haze of my mother's grief and pain of dealing with her mother's loss, it was difficult for me to express my feelings about what was going on in my own head, especially when I first saw my grandmother after her amputation. As I mentioned earlier, I always have been uncomfortable with the notion of "disability." Whereas before I could be in a public space and turn away from a man missing his arm, now I had to face my grandmother on a day-to-day basis, a woman whom I admired and looked up to who now was the embodiment of the thing I feared. My initial interactions with my grandmother were guarded at best, and I was not sure how or if my close relationship with her would change because of my ability or inability to cope with what was going on. As a sheltered 12-year-old girl, I now had to adapt to a new framework and pedagogy (I didn't quite think of it in those terms then, but on reflection, that was what was happening).

Carrying a great deal of built-up anxiety, I went to visit my grandmother in rehab. The concept of rehabilitation and what this implies for a person who has just lost part of a limb is explained by Barnes and Mercer (2003) in their discussions about Morris (1989) regarding rehabilitation: "It is very apparent that rehabilitation discourse is invested with a moral notion of what bodies should be like" (p. 83). Society has created a prototype for what "normal" looks like, putting emphasis on the body and physical appearance as defining an individual's ability or (dis)ability. This concept of body perception relates to Leder (1990) and Merleau-Ponty's (1962/2005) theory of the body and self. As I neared the rehab, I continued to naively put emphasis on body image and my perception of what a typical body should look like. I was petrified at what I would see and how I would react. Upon entering the facility, I saw the light in everyone's face and the "normalcy" in which they were living their lives.

One evening at the rehab center, a game night was held in a recreational room. My mother and I took my grandmother down to participate. The room was filled with 15 men and women who had varying physical impairments. One of the aides who had organized the event asked if I would run the craps table, and before I knew it, I was sitting with a crowded group of energetic individuals and laughing and

enjoying a competitive game of craps. I vividly recall that this moment brought a great deal of comfort to my mother, my grandmother, and me, as I started to realize that my fears about disability were due to my lack of exposure and knowledge. Disability was no longer the elephant in the room, and I was not turning away anymore from the societal notion of "imperfection." I began to feel a strong need to spend time with my grandmother and the other men and women I had met at the center. I was visiting once a day after school and building relationships that, to this day, have played a pivotal role in my decision to study disability. I began to consider my relationship to representations of disability on television and to question the resulting perceptions I had developed regarding disability. This relates to Huntemann and Morgan's (2001) discussion: "It is important to stress that young people also actively *use* media to define themselves, and media can help children and adolescents make sense of their lives as a form of self-socialization" (p. 312). This accentuates the way the media defined parts of my developing identity as I was receiving messages regarding differences that influenced my value system.

Phenomenology and Television Viewing: The Affect and Effect on Me

Although there is some dispute about the level of influence the mass media has on our perceptions of the world, there are relatively few who would argue that it does not have any. (Barnes, 1991, p. 46)

I watch a lot of television. Some nights, it consumes me to the point that one show bleeds into another, and I almost don't know where one has stopped and the next one begins. As I have relied on television so much to be entertained and enlightened, I also have realized that its ability to represent the "other" (i.e., a woman in a wheelchair, a teenager living with Down syndrome, or a person with autism spectrum disorder) has huge gaps. Television was a huge part of my childhood. My Eastern European grandparents considered it to be a hero/teacher/friend of sorts, since it helped them learn English when they moved

to the United States in their early 20s. One of my first memories was my Polish grandfather, in broken English, trying to solve the puzzle on *Wheel of Fortune* with only one letter on the board. Nine times out of 10 he would guess the phrase to be "Toot Toot Toot Sie, Goodbye." My brother and I thought he was doing it to get a good laugh out of us, but looking back, I think he thought he had it nailed. To feel like he was "fitting in" to the cultural norm of television viewing, my grandfather worked hard to create a dialogue with the host of the game show and participate in the show's spectacle. Television viewing was connecting my grandfather to my brother and me, since we all shared the joy of watching it together. Age, gender, and educational backgrounds were blurred as we were drawn into a simplistic, family moment. Postman (1994) describes: "The essential point is that TV presents information in a form that is undifferentiated in its accessibility, and this means that television does not need to make distinctions between categories 'child' and 'adult'" (79).

Another early memory of television viewing was with my mother. An integral part of our relationship from the time I could hold my head up was her propping me up on her knee with one hand and folding laundry with the other while she watched her favorite soap opera, *All My Children.* I didn't understand much of what was going on at age 2, but I did know that my mother was enraptured by the characters and the glamorous lives they led. The line between childhood and adulthood was blurred as television became a permanent fixture in my everyday experiences (Postman, 1982). Houston (2000) discusses the process of watching television using Freud's concept of the ego, which primarily deals with the individual's ability to make sense of his or her reality; creating a need for pleasure and satisfaction to be met immediately, the ego slows down this process and allows for organization of external objects and circumstances to be directed (Freud, 1923). In relation to television, Houston (2000) states, "It [television] offers an extraordinary promise of endless flow, which is repeatedly blocked for the spectator by interruption in the delivery of the text" (p. 204). She goes on to say that as the ego struggles to stay in control of the overflow of information and organize it, the actual object itself gets lost (Houston, 2000). As individuals are bombarded with various pictures,

words, and symbols, the intended message from the producer often is lost as the viewer tries to keep up with all of the material being broadcast. In large part, media are a distraction from the everyday hustle and realities, an escape into another dimension, albeit temporary.

The comfort that television seemed to bring to our home influenced my later infatuation with it. Television gave us something with which to connect. Through watching television, the common, everyday housewife breaks out of her suburban container to go on a journey with exciting characters and fantasy situations, all the time believing that her daily activities of folding the laundry and cleaning up puke are a walk in the park compared to Erica Kane's (Susan Lucci on ABC's *All My Children*) multiple divorces and trust issues. The images and scenarios to which I was exposed at a young age avoided any representations of disability. Perhaps I would catch a glimpse of a character in the background of a scene sitting in a wheelchair or see a dramatic car accident in which a character becomes paralyzed and then, by some unforeseen miracle, becomes "cured." The tragic "creation" of a disabled person always seemed to be a "worst-case scenario," and a cure was demanded in the plot. I cannot remember a character becoming disabled and leading a fictional life as disabled for the duration of a show. This pattern of watching disability as an obligatory storyline, or for unrealistic melodramatic effect in soap operas, set a tone for me. I saw people with differences, but I did not understand their differences and capabilities. In the early 1980s, my parents purchased a VHS recorder, and my mother was able to record the daily soap opera episode and watch it with me before my bedtime. There was no more differentiation between what my mother and I were watching, and the television was left on for hours on end as a permanent fixture in my home. Postman (1982) suggests that "The plain facts are that television operates virtually around the clock, that both its physical and symbolic form make it unnecessary—in fact impossible—to segregate its audience" (p. 82).

Television became my built-in playmate. It ranked with my Barbie dolls, and I began to see my family and myself as caricatures on our own sitcom—*The* (Postman, 1985). As a TV star, I began to create my own television programs with anyone who was willing to accept a starring role. If they didn't want it, the part would go to me. I became

fascinated with my father's bulky video camera. I was the master of my domain, and I could recreate anything I saw in a television show and make it my own (Simpson, 2004). I was living in and through a true media culture, basing much of my understanding of family life, schools, and relationships on what I was seeing on television. I was identifying myself with television and building my experiences around its media representations. Kellner (1995) provides some insight into this common phenomenon: "A media culture has emerged in which images, sounds, and spectacles help produce the fabric of everyday life, dominating leisure time, shaping political views and social behavior, and providing the materials out of which people forge their very identities" (p. 1).

As I grew, I realized more and more that television helps create the prototype that society has accepted as "normal," and it has become so innately constructed that it is rarely questioned. Thus, as my relationship with the media continued to develop, I recognized that Manhattan, New York, was the best place in which to pursue my interest and passion for this television culture (Gauntlett, 2002/2008).

Shifting Careers: Building a New Foundation

The lights; the skyscrapers; thousands of people crowding the streets to get to their destination, be it work, a show, an art gallery, or rehearsal, make New York City a place unlike any other in the world. It is a mixture of high and low cultures. One has to compete with the intensity of a prizefighter to make a mark, but if desired badly enough, greatness is attainable. I always have felt a connection to Manhattan. I grew up 35 minutes north of "The City" and would often take trips into the city after school to see a Broadway show or a ballet. I was infused with artistic culture by my parents, and like most young girls in my neighborhood, I was enrolled in dance classes from the time I could walk. Theater classes came later, but the feeling of wanting to break out of my shell and exude excellence was creeping up faster than I could contain it. Living so close to a place that contained so much opportunity for greatness placed me in a position to want to reach for it. As Frank

Sinatra reflected, "If you could make it there, you'll make it anywhere" (Ebb & Kander, 1977).

As my fascination with television grew, it became such a fundamental part of my life that I applied for the Mass Media in Communications program at New York University to study the science of television viewing. There, I was thrust into the world of theories regarding the implications of watching television and the manipulation of the media to present a message to an audience that would ultimately result in consumption of a product or ideal lifestyle. Postman (1985) suggests that

> Television is our culture's principal mode of knowing about itself. Therefore— and this is the critical point—how television stages the world becomes the model for how the world is properly to be staged. It is not merely that on the television screen entertainment is the metaphor for all discourse. It is that off the screen the same metaphor prevails. (p. 92)

As I was using television to educate me on the various situations and ideologies being formed, it was a compelling indicator of how much my consumption and the values systems I had built were based on its influence.

Jenkins (2006) points out that "once a medium establishes itself as satisfying some core human demand, it continues to function within the larger system of communication options" (p. 14). As I gathered more information and the realities about media began to take shape, I began to feel disillusioned about my career choice and more curious about how the media dominated the reality I was living and its impact on my conscience.

I started doing production internships at big corporations: ABC, Viacom, and the *New York Times*, as well as some small-scale public relations firms in lower Manhattan. I felt myself caught up in the notoriety that came with these big names. My perceptions of television became more negative as I realized the power of corporations to influence them, thus making me second-guess my decision to make this a lifelong career.

After graduation in May 2002, I began working as an assistant publicist for business books with the publishing company HarperCollins.

I was catapulted into a world of cutthroat work ideals that would include late nights, brownnosing, and a lot of letdowns. The world I was building around media was straying far from what my childhood imagination thought it would be. I turned my attention to education, an interest that had always crept in and out of my life, and set new goals for what I thought was important: educating children through the media, using it as a tool to learn rather than as a narrow escape. Thinking back to my father's positive experiences as a teacher, I felt pride and admiration. It was a feeling that motivated my future decisions about working in an educational context where I hoped to leave my mark on students with various learning abilities and differences.

Recalling an Anecdote from My Father

I remember it like it was yesterday—it was 1989, and I was nine years old. Jack, my father, a fairly tall, athletic man, would come home from teaching school around 4:30 p.m.; sometimes he would run to teach at his second job, which was Holocaust studies at a reformed Hebrew school, or to play basketball with a group of men around his age. On this particular evening, my family—consisting at the time of Jeremy (a brother five years older than me) and my mother Randi—had the opportunity to sit down together for a hot meal and reflect on our day. Most nights this would happen with the hum of a small, beat-up, 20-inch, black-and-white television on the kitchen countertop, which needed a hit every five minutes to stop the picture from scrambling. But tonight, my father wanted it off, and although he generally liked to disconnect from his school day and just relax and talk about sports or the most recent funny episode of *Married with Children*, tonight he wanted to share his challenging encounter with a boy I will call Adam, an 11th grader. My brother and I were not really sure how to take it. We were used to kicking each other underneath the table during "family dinners" and rapidly finishing our meals so we could go back to playing Nintendo.

However, this time, things seemed different. Adam, as my dad began to tell us, came from a dysfunctional family, and this, in turn, led

him to suffer from emotional delays, which affected his ability to function in school. My father had been asked by the chair of the special education department of his high school to accept Adam as a member of his journalism class. She hadn't given him many details about Adam's background, but she felt that he had a lot of untapped potential. My father, generally a pragmatist, also had a son around Adam's age and felt that he could potentially be in a position like Adam's one day. He reluctantly agreed and said that he would give Adam a chance to shine.

The next day, Adam entered Dad's class. Dad described him to us as a shy, almost reclusive young man who crept to a seat in the last row of his classroom. During the class, he explained the requirements of the writing course to the students: as the writing class, they were responsible for publishing the school newspaper. As a result, the students were required to fill the various jobs of making a newspaper (e.g., reporters, editors, photographers, etc.). By the end of the class, Adam was the only pupil who had not volunteered for anything. He sat timidly at his desk with his head bent forward and his shoulders hunched. After my father dismissed the class, he asked Adam to stay so he could speak to him about his problem. Adam explained that he did not want to write anything that the school would read because he had heard countless times that he was "stupid," "incapable," an "underachiever," and "a waste of time."

My father told Adam that he had a lot of reflecting to do and that he wanted him to come back to class tomorrow ready for a challenge. The next day, my father told Adam that he had thought it over and would make a deal with him. If he were willing to write a story for the paper, he would allow him to use a pen name so that no one would know who wrote it and that it would give him the freedom to critique anything he wanted. Begrudgingly, Adam agreed, and he wrote a scathing article criticizing school policy. Not only was it well written, it also had a maturity about it that proved that Adam had a latent talent for writing. Adam chose the pen name *The Terminator*. After the paper was published, no fewer than 20 students came to Dad's office to inquire as to the identity of the writer. When my father mentioned it to Adam, he was shocked to the point of disbelief. For the first time in his life, he had been recognized and complimented

for something he had done. This lit a fire under him, and he began working on his next article while others in his journalism class went to him for ideas and editing advice. Adam decided not only to be a writer but also an editor for the newspaper. His shyness faded and the wall of mystery came down as he confessed to the school who he was. He started walking the hallways with a confident swagger, and he actually started making friends. His turnaround was so profound that at Adam's request, the principal allowed him to take my father's journalism class for a second year as an advanced class. For his senior year, Adam became editor-in-chief and ran the entire newspaper. At the conclusion of his story, my family and I felt deep pride and admiration for both my father and Adam. For the first time, I saw my father's profession as a tool to empower those in difficult learning situations and give them a voice. According to Kincheloe (2005b), "Advocates of critical pedagogy are aware that every minute of every hour that teachers teach, they are faced with complex decisions concerning justice, democracy, and competing ethical claims" (p. 1). It becomes the responsibility of the educator to know the background and situation of the students, and this will allow for a deeper understanding and more effective way to teach, as each student carries with him or her a past and a story.

Cultural theorist Paulo Freire's (1970) influential *Pedagogy of the Oppressed* examines the importance of empowering students with differences. Freire discusses the power of the perspective of humanization, especially since society is so rapidly becoming dehumanized. Freire states, "Within history, in concrete, objective contexts, both humanization and dehumanization are possibilities for a person as an uncompleted being conscious of their incompletion" (p. 43). My father's guidance to help Adam fulfill his hidden potential by creating a trust between them contributed to "humanizing" Adam. As a result, Adam was able to build the confidence he needed to and grow his latent aptitude.

Through the years, I asked my father about Adam, always eager to hear about where he was going and what he was doing. My father informed me that after Adam graduated from high school, they stayed in touch while Adam was in college. Adam was a rising star

at the university as well. He began as a writer for his school newspaper, and by his senior year he was editor-in-chief. After graduating from college, Adam achieved his ultimate goal: he became a sports writer for a local Connecticut newspaper. My father was proud of the strides his student had made from being a battered, emotionally broken-down, introverted adolescent to a consummate, confident professional. My father and Adam eventually fell out of touch. One evening, out of the blue, my father was contacted by Adam's mother, who after months of looking for my dad told him that Adam had just written his first sports book. She requested that he surprise him at a book signing, where he would be equally surprised at the great honor of having Adam dedicate his book to "the teacher that guided him." This moment from my father's career turned my thoughts toward education and the needs of students, as I realized that so much of a student's success or failure relies heavily on the teacher and that all-important connection and trust between a teacher and a student. Much of the research indicates that a positive relationship between a teacher and student positively influences a student's performance and overall attitude. Adam's story helped me realize how vital a healthy student/teacher relationship could be. It made me realize that teaching students involved far more than just presenting information. A quality teacher takes the time and effort to establish a trusting relationship with his or her students. My perception was forever changed, and I never looked at teaching or teachers again in quite the same way (Niebur & Niebur, 1999).

Stepping into Inclusion

Public debate over the role of media usage in shaping values and attitudes increases every year. Numerous studies have demonstrated predictable correlations between school performance and children's use of media. (Dorr & Rabin, 1995, p. 323)

While New York kept my energy high and my cultural addictions fed, I felt a part of me was not being fulfilled. I always had a deep

connection to education and kept it in the back of my mind as I navigated career paths. I owe this to my father, a successful English teacher for more than 30 years who passed his passion and energy on to my family and me.

The work of Paulo Freire influenced my life during the first year of my doctorate journey. In reflecting on his theories about education and human beings, I was reminded of a quote from *Pedagogy of the Oppressed* (1970): "Man's ontological vocation is to be a Subject who acts upon and transforms his world, and in so doing moves toward ever new possibilities of fuller and richer life individually and collectively" (p. 32). Freire's words sum up what has helped guide my transition from entertainment to academia, as I became both a student and a special education instructor working with students.

When I came to McGill University in 2004, I was eager to start the master's program in inclusive education in the Department of Counselling and Psychology. Admittedly, I felt I didn't fit because my bachelor's degree was in Mass Media and Communications Studies. My only *real* knowledge of children and education came from the day care centers that I worked in intermittently after graduation. I didn't really know what I was getting myself into. I was thrust into a world quite different from the one I had known during my schooling in New York.

In a course called Special Needs 1, I was able to make connections to my past experiences with disability and get more in-depth explanations for the various syndromes, disorders, and deficits that affect millions upon millions of children and significantly impede their ability to learn and be understood. An opportunity to work in an inclusive setting with a child diagnosed with severe learning deficits and emotional problems became available to me through some early-intervention work I had been doing in various Jewish kindergartens around the greater Montreal area.

As I observed the child—in grade 4 with his six other classmates, one lead teacher, and one assistant who spent part of their day out of the "mainstream" classroom while the other students in the school learned French, English, and Hebrew—I became engaged with how these students embraced their learning environment and was fascinated with

their ideas about how they learn and how they perceive themselves as alternative learners in comparison with the other students in their school. The students in the special needs classroom had disabilities including problems with decoding, language and processing delays, attention deficit disorders, and low self-confidence. In the special needs classroom, the students would have an opportunity to work in smaller groups on social skills, reading, writing, mathematics, language acquisition, and building self-confidence. I spent four months in the special needs classroom and was more challenged working one-on-one with my fourth grader than I had been working in any other sphere. With the rigor and intensity of learning in the Jewish elementary school, the inclusive students merged with the other students during cultural celebrations, some English instruction, physical education, lunch, and recess. The remainder of the time, the inclusive students followed individualized education plans (IEPs).

In trying to find the most effective mode to educate my student and help him grasp simple concepts, I was challenged to connect with him in areas in which he was interested, for example, computers, cartoons, and popular movies. As the cultural psychologist Lev Vygotsky (1987) notes, "The teacher must orient his work not on yesterday's development in the child but on tomorrow's" (p. 211). Due to ongoing difficulties at school, in and outside of the classroom, most of these children have lost their motivation for learning and are more interested in keeping up with the status quo. They desire the newest gadget and/ or the most popular computer game and television show being talked about rather than learning basic math or sitting down to complete a skill builder's worksheet.

The American Academy of Pediatrics (2013) points out that "[i]n a matter of seconds, most children can mimic a movie or TV character, sing an advertising jingle, or give other examples of what they have learned from media." (p. 1). As our time working together came to a close, I felt I was being pulled away from children who were extremely misunderstood and misrepresented. Hoechsmann and Low (2008) argue for the importance of situating literacy and listening to words that children speak to get a sense of their cultural context. This type of

discourse was not happening within this classroom, and the students were frustrated and the teachers impatient.

By some incredible twist of fate, the future of the special needs classroom was undergoing some major restructuring, because the success rate and comfort of the students was not satisfactory. The timing was perfect. I would be graduating from McGill with a master's degree in inclusive education that May, and I was asked by the administration if I would become a lead teacher in the fall in the expansion of the special needs classroom. I accepted the position because I felt that I could use the opportunity to employ media to motivate different learning styles, and to explore the way ideologies and beliefs were shaped by students. This opportunity was the beginning of my explorations with representation of disability in the media. I began to critically study and practice in areas of inclusion and special needs learning in the classroom. I did this by observing children and gaining more personal insights into their family backgrounds and past learning experiences. I learned that a large body of research and knowledge related to education and pedagogy was available for a world that would fundamentally affect my role as an educator. Exploring pedagogy more in depth, I yearned to work more closely with students and bring learning to life, giving each student the room to grow and discover his or her strengths at his or her own pace. To me, pedagogy, inside the classroom, enhances the effectiveness of education by allowing each student to express himself or herself individually and not be an automaton (Freire, 1970).

Informing the Informer

After I realized that part of my life journey would involve the study of disability in the media, I began to research the various theories and methodologies associated with this discipline to help ground my work and provide a basis from which to begin. To do this successfully, with the help of my supervisor Dr. Shirley Steinberg, I was introduced to social and critical theory. Understanding the foundational theories of critical theorists such as Baudrillard, Postman, McLuhan, Freire, Gramsci, Corker, Kellner, Giroux, and Kincheloe would help inform

the work I intended to do in my graduate study. Complementary to these theorists are the concepts and epistemologies they built to help their audiences understand the areas they are critiquing. To support my intention to become a rigorous researcher, I have adapted these concepts to my own interest in the representation of disability and its role in the media (Kincheloe & Berry, 2004).

Influence of Functionalism

The theoretical concept of functionalism is used widely in contemporary sociological studies to explain the systematic elements needed to maintain organization and function (Flecha, Gomez, & Puigvert, 2003). The purpose of applying functionalism to the larger framework of my research on disability representation on popular television is to build on the conceptualization of *societal norms* as they are applied collectively to individuals. Regarding early functionalism circa the 1950s, social science had close ties to the biological sciences in that just as physical science uses the digestive system, nervous system, etc. to organize itself, so does social science use the functioning of social systems based on the organizing principles of politics, capitalism, etc. In terms of disability, individuals are placed within "systems" and "structures" that map out where they should go as a way to define their usefulness to society: "The function of structures is to contribute to the maintenance and adaptability of the systems which they belong" (Flecha et al., 2003, p. 9). Generally, functionalists argue that a certain degree of inequality is functional for society as a whole, and that society could not operate without a certain degree of inequality.

Social theorists such as Talcott Parsons (1951) and Émile Durkheim (1960) have made significant contributions to the development of functionalism. Parsons's interpretation of the doctor/patient role and the impact of "sickness" on the rights and responsibilities of the patient contributes a great deal to how functionalism has influenced the development of disability theory (Barnes, Mercer, & Shakespeare, 1999).

Although functionalism has a solid foundation in the social sciences, it has been criticized as being a conservative theory that favors previous social structures that continue to dominate our present. Overall, there is no way to empirically argue the validity of certain social systems such as family, or employer and employee status, which undermines the validity of functionalism. These are systems that are not replaceable by other, more efficient means (Flecha et al., 2003).

How to Account for Representation

The "representation of the Other" is a significant concept of cultural studies that has further influenced my research. The concept of *representation* implies a concrete form based on a system of signs: "The representation entity outside the self—that is, outside one's own gender, social group, class, culture or civilization—is the other" (Sardar & Van Loon, 2010, p. 13). When applied to disability, the representation of the other signifies the uncommon denominator that is disability as it falls out of the "norm" of Western society. The influence of postmodernist and poststructuralist paradigms, on both cultural studies and critical disability studies in education, has used the concept of the "other." Within this framework, the term *difference* has added yet another dimension to representation. Garland-Thomson (2009) states, "Because we come to expect one another to have certain kinds of bodies and behaviours, stares flare up when we glimpse people who act in ways that contradict our expectations" (p. 6). In fact, "the construction of difference" and the "process of assigning value to difference" are central to the understanding not only of disability but also of many other forms of oppressive beliefs (Rothenberg, 1998, p. 281).

The systems that produce representation are the cultural circuits through which meanings are transmitted. As individuals coast through their everyday lives, the means of representation embody concepts, ideas, and emotions in a symbolic form that can be transmitted and meaningfully interpreted. Some important systems of representation include the media in all its forms—especially television and the print

media—films and videos, music lyrics, museum exhibitions, and all aspects of society characterized by "text and talk" (Lemesianou & Grinberg, 2006).

To maintain an awareness of myself as an avid television viewer with a background in mass media and communications theory, I am always taking a step back from my initial reaction to what is being implied through the message. As Lemesianou and Grinberg (2006) state, "the point is that representations always convey meaning and that meaning is contextual and contingent to its milieu" (p. 222). Every day, society is saturated with hundreds of media images in which individuals or whole groups of people are featured and looked upon within a particular context, often perpetuating a "norm" set up by a power producer (Kellner, 1995).

Within a postmodern framework, there are some significant ideas/ theories/perspectives on how disability should be represented. What has been analyzed thus far does not necessarily emphasize the important areas in need of research. For instance, North American theorists and those theorists from Great Britain differ in the definitions and contextual frameworks they use. American theorists such as Hahn (2010), Albrecht (Albrecht, Seelman, & Bury, 2001), Amundsen (1992), Rioux and Bach (1994), Davis (2013) and Wendell (1996) explored significant and critical frameworks of disability from aspects ranging from social/ cultural to political but have not done much work to modify the current definitions of "disability." This differs somewhat from the British point of view, including Hasler (1993), Barnes (1991), and Oliver (1990, 1996), who place more emphasis on the social model of disability over the biological interpretation (Shakespeare & Watson, 2002).

It's a Sign of the Times: Structuralism

The structuralists and their heirs embrace language as the dominant model for theorizing representation, interpreting nearly all symbolic behavior in strictly linguistic terms. (Siebers, 2008, p. 2)

Based on the work of Ferdinand de Saussure, structuralism is linguistic in origin and reflective of cultural systems and signs that are

analyzed for their structural relationships. Flecha et al. (2003) describe structuralism as having "objective structures, independent of the agents' consciousness and will" (p. 36). Sociologist and educator Pierre Bourdieu was one of the main contributors to the theory known as structuralism. Bourdieu argued that individuals as agents of society are unable to freely choose their realities. Two central concepts developed by Bourdieu are *habitus* and *cultural capital*. *Habitus* is described as a "structuring structure that organizes the practices and perception of the practices" (Flecha et al., 2003, p. 17). *Cultural capital* is the ability to "read and understand cultural codes" (Sardar & Van Loon, 2010, p. 72).

The effect that structuralist theory has on critical disability studies in education is twofold:

> First, because linguistic structuralism tends to view language as the agent and never the object of representation, the body, whether able or disabled, figures as a language effect rather than as a causal agent, excluding embodiment from representational process almost entirely. Second, theorists influenced by the linguistic turn infrequently extend the theory of representation from mimesis properly speaking to political representation. (Siebers, 2008, p. 2)

Looking at the poststructuralist analysis of deconstructing language and interpreting hidden representation has helped "give voice" to those who are powerless (Barnes & Mercer, 2003). All too often, disability is lumped together with sexuality and race and is never quite on its own footing in the social sciences discourse (Corker & Shakespeare, 2002). As more and more questions about marginalized individuals arose, Roland Barthes (1964) contributed to this ongoing conversation by asking: What is the process by "which men give meaning to things?" Barthes argues:

> Of course the world has never stopped looking for meaning of what is given it and of what it produces; what is new is a mode of thought (or a "poetics") which seeks less to assign completed meanings to the objects it discovers than to know how meaning is possible, at what cost and by what means. Ultimately, one might say that the object of structuralism is not man endowed with meanings, but man fabricating meanings. (p. 1130)

As essential as it is to consider the importance of structuralism to help ground my research, it also is crucial to look at the implications that culture has on media and disability.

The Acculturation of Media

Media culture falls under the umbrella of cultural studies and imposes its own set of criteria for a definition. Kellner (1995) argues, "Media culture in the United States and most capitalist countries is a largely commercial form of culture, produced and disseminated in the form of commodities" (p. 16). Popular artifacts are produced for public consumption, and therefore, they become the dominant value system of individuals. Baudrillard (2003) made the claim that

> the entire society is organized around consumption and display of commodities through which individuals gain prestige, identity, and standing. In this system, the more prestigious one's commodities (houses, cars, clothes, and so on), the higher one's standing in the realm of sign value. (p. 313)

Keeping in mind the specific agendas that the culture industries explicitly place on societal values helps us understand the "social discourses which are embedded in the key conflicts and struggles of the day" (Kellner, 1995, p. 14). Also, a closer examination of contemporary culture and popular texts, for example, television programs, hip-hop music, celebrities, and top news stories, will help draw together dominant ideologies that help shape culture and society (Kellner, 1995).

The complex way of sending and receiving messages at rapid speeds through various media outlets has helped support the powerful impact of the media and culture discourse. McLuhan (1967) and Sardar and Van Loon (2010) describe four basic components of the media industry involved in the packaging of messages and products:

- The message or product itself
- The audiences who imbibe the message and consume the products
- The ever-changing technology that shapes both the industry and the way the message is communicated
- The final look of the product (p. 155)

The ability of an audience to absorb a message sent by the media directly affects the way the individual perceives its social implication. Steinberg (2006) states:

> What appears to be common-sense dissipates slowly into the ether, as electronic media refract the world in ways that benefit the purveyors of power. We have never seen anything like this before, a new world—new forms of social regulation, new forms of disinformation, and new modes of hegemony and ideology. In such a cyber/mediated jungle new modes of research are absolutely necessary. (p. 117)

As a student of the media, I am particularly interested in why culture, specifically popular culture, has had a substantial impact on society and why so many of us have come to know (or think we know) the "truth" based on what we absorb from the media. According to Steinberg (2006), "Mass Culture is imposed from above. It is fabricated by technicians hired by businessmen; its audiences are passive consumers, their participation limited to the choice between buying and not buying" (p. 118). This theory about the fabrication of mass culture will be useful for grounding my point of view about disability as I examine how disability is represented in the media. As I grapple with my position and my personal connection to disability, I find myself asking questions about the responsibility of media to its audience and whether media responsibility is even an issue. Have significant strides been made in this area, or are we still watching a silent struggle over what is perceived and what is an accurate representation? There is no such thing as "fair" and "balanced" so long as the corporate world wields such enormous control over what "reality" is being disseminated.

Conclusion

My intention for this chapter was to weave into my personal narrative various concepts of critical theory, to become a *bricoleur*—one who draws from different areas of research to create a meaningful body of work—and bridge the gap between academia and personal narrative. Foucault (1984) defines "techniques of the self" or "arts of existence" as

those reflective and voluntary practices by which men not only set themselves rules of conduct, but seek to transform themselves, to change themselves in their singular being, and to make of their life into an *oeuvre* that carries certain aesthetic values and meets certain stylistic criteria. (pp. 10-11)

The motivational force behind certain bodies of work and the desire to achieve more in the field of academia is significant when doing a self-reflective study like this one. Weiner (1992) uses the metaphor, "people are scientists, trying to understand themselves and their environment and then acting on the basis of this knowledge" (p. 2). Looking at the self also raises questions about ideology and power. The dominant discourse in my case is disability and television and the deep-rooted effects that representations of disability on television have had on my consciousness. A theoretical examination of ideology and how it influences/creates societal norms is crucial when defining media culture, as Kellner (2003a) argues: "Ideology assumes that 'I' am the norm, that everyone is like me, that anything different or other is not normal" (p. 61). According to Kincheloe (2005b), *ideology* is "meaning making that supports forms of dominant power" (p. 2). Representation commands our everyday encounters as a direct influence on our belief systems.

As I pull together the pieces of the puzzle that have brought me to my current place in society, I am faced with some conflicting issues, which include wanting to use the media not only for entertainment and educating elementary and high school students but also being mindful of the negative influences and overdependence of individuals on the media for their access to information. In this introductory chapter, I have recounted my earliest memories of media and disability and connected them with the various stages of my development through childhood and into adulthood. I have discussed the paradigm shift that I experienced as I moved from the glitz and glory of a career in high-energy, fast-paced New York City to a more grounded career working in education with children who have learning differences in a private Jewish elementary school.

In the chapters that follow, I provide a literature review, a further expansion and articulation of my chosen methodology (bricolage), and

an in-depth analysis of media representations of youth with disabilities on popular television programs. The goal of this study is to create awareness of marginalized groups and look at the limitations and strengths of disability representations.

Chapter Two

Mapping Out Disability

Stereotype assumptions about disabled people are based on superstition, myths and beliefs from earlier less enlightened times. They are inherent to our culture and persist partly because they are constantly reproduced through the communications media. We learn about disability through the media and in the same way that racist or sexist attitudes, whether implicit or explicit, are acquired through the "normal" learning process, so too are negative assumptions about disabled people. (Barnes, 1992, p. 5)

Introduction

The focus of this chapter is an examination of the various theories and philosophies that both support and discredit the use of media as a tool for empowering individuals living with disabilities. I look at network television as a form of popular media that has become a driving force in the portrayal and propagation of the various roles and stereotypes of contemporary culture. This approach allows me to explore the power

of this media in representing marginalized groups and in transmitting its messages to children/youth and to delve deeper into how the standards that the media have constructed might influence the development of the self-image of individuals living with disabilities.

Individuals living with disability often are misrepresented and discriminated against because of their differences (Barnes, 1991). For a generation that relies heavily on the media for introduction and exposure to marginalized and underrepresented groups, it becomes essential to acknowledge how media affect the masses. Television, and in particular network television (ABC, CBS, FOX, NBC, etc.), is central to our daily lives. Watching television gives an audience a media/ socially constructed view into the lives of individuals from various religious, ethnic, sexual, and economic backgrounds. With that phenomenon in mind, through my research, I examine the influence of media on disability and how media works to socialize disability. This chapter has four key sections that discuss the most important concerns of disability and media studies. I begin with an introduction that explains why I chose disability and media as my topic of interest. Next, I look at disability studies and how the "disabling image" was created and reinforced by the rise of television. This is followed by a historical overview of television as a socializing tool for youth that influences popular culture and serves as a means to teach critical pedagogy and educate youth. Last, to build a strong foundation for the remainder of the study, I summarize my literature review, which examines the theories that have been formulated to understand the discourse on disability in the media.

The Importance of Looking at Disability and the Media

Contemporary human beings obtain a great deal of cultural information from television, which affects the ideological development of the self and remains palpable as schooling begins and connections are made between individuals. Many studies have examined the long-term effects of television viewing on the behaviors and attitudes of

individuals (Gebner, Gross, Morgan, Signorielli, & Shanahan, 2002; Jenkins, 2006). It is important for researchers to take note of the absence or misrepresentation of marginalized groups (i.e., television characters with disability), as their representation has been minimal at best. This absence is significant given that more than 10 percent of the world population lives with some form of disability (World Health Organization, 2010). This population is affected by the many distorting images carried by the media. For example, Goggin and Newell (2003) point out that "[i]ndeed we can see that increasingly TV as a sociopolitical space has disabled people, but because of its dominant understandings and power relations we located the blame with deviant individuals we know as disabled" (p. 90). The way that television mirrors popular culture has led me to question its ability to accurately represent disabled youth. The standards of the mainstream media still seem to represent white, thin, able-bodied, attractive individuals. The overarching question examined here is: How are youth with physical or emotional differences represented in the media? Since the Internet and social media play such fundamental roles in the everyday lives of young adults, and new methods have arisen to express ideas, issues, opinions, and current events, it is the role of educators and activists to start a conversation about the effects of these media representations, which wield a great deal of power to shape the beliefs of individuals.

Looking more closely at Baudrillard's (1995) use of the term *hyper-reality* (i.e., the reproduction of an event that seeks to replace reality or consciousness), his contemporary view of popular culture raises questions about what we are doing when we watch television, what types of shows attract viewers, and, more broadly, what is popular culture. Steinberg's (2011) research examines the role of popular culture in transforming the ideologies of youth through popular media platforms. This becomes significant to my research on media representations of disability because so much information is obtained through avenues of the media, and media are setting the tone for how differences are perceived.

It therefore becomes necessary for academics, social theorists, educators, and students to consider the following questions:

- How are individuals with a disability represented on network television programs?
- What are the prevalent issues with respect to stereotypes, education, bullying, representation (or misrepresentation), and tolerance?
- What are the ideologies that underlie media representations of disability?
- What are the social implications of using network television programs as educational tools to teach children/youth about marginalized groups?
- Considering the power of mass media to shape popular ideas and attitudes, what are the mechanisms that media use to maintain or change the perceptions of society toward disability?

In addition to the questions raised in Chapter 1, these questions have guided my research, not to provide direct answers and solutions to the recurring issues associated with representations of disability in the media but rather to raise awareness and contribute to a dialogue about the importance of changing the representations of disability in popular culture—and to pedagogically effect a change in the attitudes of audiences.

Schwoch, White, and Reilly (1992) described media as "a site of perpetual pedagogy" (p. xvii). Building on this idea, Steinberg and Kincheloe (2004) noted that "corporate-produced children's culture has replaced schooling as the producer of the central curriculum of childhood" (p. 11). This shift in teaching and learning created a new set of values and standards in education. Technological innovations have given knowledge a new form and quality, leading Kincheloe and McLaren (2008) to identify dominant cultural producers as the "new educators" in contemporary society. Traditional schooling has become less relevant to what Steinberg and Kincheloe (2004) termed the "new childhood" (p. 2), a place where children have continual access to "adult" information through media and corporate culture. Despite this shift in values, Steinberg (2006) added that "in the postmodern condition the pedagogical effects of popular culture have often been left unnamed" (p. 25). Youth culture is driven, to a great extent, by the language and

chosen images of media that bring young people together, acting as a common denominator, which is much more appealing than traditional school subjects.

Media play an enormous role in the education of children, and my research raises questions, concerns, and debates about how and why network television has such an important place in popular culture, with its easy access and constant marketing to the masses. The goal of my research is to contribute to the discourse of critical pedagogy to reconceptualize education in the context of the complex world of hyperreality or in the blurred space of reality and fiction. As Baudrillard (1994) argued, *hyperreality* refers to those events in mass culture that are reproduced or copied and that seek to replace the original, for example, Disneyland. Acknowledgment of new trends in education holds a great deal of significance, since it allows educators to better connect to their students and teach to their interests. The move away from a traditional, teacher-led pedagogy helps create a more student-centered environment, which allows for more open and critical engagements and discussions between students and educators. This happens when educators are aware of the interests and backgrounds of their students, which they can use to engage them; thus, the student-centered approach encourages more participation and activity on the part of students. Students are strongly motivated by messages from advertisers and youth-inspired television programming, and they hold onto these mental images for long periods of time (Media Literacy Project, n.d.). In other words, educators need to address the living and learning that takes place outside of schools, such as the impact of television viewing on young people (Douglas & Jaquith, 2009; Steinberg, 2011).

I critically consider disability through a media lens, specifically television, as a sociological framework, and keeping in mind that disability encompasses various characteristics, I focus on representations of both physical and cognitive disabilities and consider how network television is used as a platform to represent the disabled community. I also consider whether any representation (positive or negative) is better than no representation at all.

Disability Studies and the Disabling Image

In this section, I look more closely at disability from varying perspectives. I discuss and define the term *disability* from a medical perspective and, more pertinent to my work with media, disability as a social construct.

A Look at Disability

As I turn my focus to disability, I examine some of the key areas that signify this complex and socially constructed concept. The areas that I highlight include the following:

- A working definition of the term *disability*
- A historical perspective
- The social versus medical models of disability
- Disability from the media's perspective

Emerging out of the disability rights movements of the 1970s and 1980s, disability studies has gained more recognition as a discipline since the 1990s. As Gabel (2005/2009) pointed out, a special interest group that developed in 1999, Disabilities Studies in Education (DSE), held the following view: "Disability studies in education is an emerging interdisciplinary field of scholarship that critically examines issues related to the dynamic interplay between disability and various aspects of culture and society" (DSE, para. 1). Many of the special interest groups and organizations that focus on disability evolved out of the emerging research regarding the term *disability* and what it actually means to be referred to as disabled or handicapped (Gabel, 2005/2009; Roper, 2003).

To begin, I look primarily at the World Health Organization (2010) and the Americans with Disabilities Act (1990) for definitions. The World Health Organization (WHO, 2010) defines *disability* as follows:

> [It] is an umbrella term, covering impairments, activity limitations, and participation restrictions. An impairment is a problem in body function or

structure; an activity limitation is a difficulty encountered by an individual in executing a task or action; while a participation restriction is a problem experienced by an individual in involvement in life situations. Thus disability is a complex phenomenon, reflecting an interaction between features of a person's body and features of the society in which he or she lives.

In the WHO definition, the emphasis is on the limitations and difficulties facing individuals with disabilities when compared to an able-bodied society. Since the term *disability* is so generalized, it limits the knowledge and understanding of the different kinds of disabilities and impairments (both mental and physical) affecting this population of individuals. In 1990, the Americans with Disabilities Act (ADA) was developed to protect the rights of individuals living with disability. The ADA strives to look at each disability on a case-by-case basis to allow for more opportunity in the workplace and other daily activities. Piggybacking off the Civil Rights Movement of the 1960s, the ADA made great strides in preventing discrimination toward people with disabilities. In 2008, the ADA was amended and came into effect in 2009 with stricter guidelines for employees/employers (42 USC 12102et seq.). With definitions in place, a greater awareness is possible of the differences in the types of disabilities and their social impact. In recent decades, research related to the field of critical disability studies in education (CDSE) has become more substantial. Contributions have been made by various theorists and academics whose work has created more awareness and understanding of a population of individuals often misrepresented in mainstream society. Considering the large amount of research and theory on CDSE, in this section, I felt it best to pinpoint the salient themes specifically related to my research. I highlight the areas of CDSE that are significant to my work as well as the researchers and theorists who have influenced the reoccurring issues and themes. I reflect on what the word *normal* means in relation to disability, and its existence as a barrier that creates comparisons and differences. I also discuss the social and medical models of disability and the representations of disability in the media (specifically prime-time network television). It is important to note that we can only fully appreciate the stereotypical nature of media representation of disability,

and its critical impact on youth, after having traced and understood the grim history of disability (Oliver, 1983).

Historical Roots and Signifying Words. For centuries, people with disabilities have been an oppressed or repressed group. They have been isolated, incarcerated, observed, written about, operated on, instructed, implanted, regulated, treated, institutionalized, euthanized, and controlled to a degree unequal to that experienced by any other minority within the United States.

The nature of the word *disability* is complex and carries with it many negative connotations and interpretations. Disability is a minority status that does not account for age, race, gender, religion, class, or beliefs. Anyone can be afflicted by disability. Disability can arise at birth or from a car accident, medical negligence, or a debilitating illness. Defining *disability* is complicated because it covers such a broad range of situations and ways of being. To label a person *disabled* has historically meant that he or she does not fit the norms of society. The notion of norms also is complex (Davis, 2013, p. xv; Doob, 1994; Goodley, 2011; Shapiro, 1999).

Davis (2013) notes that the word *norms* has its origin in the 1800s as a standard or ideal in which something could exist; in other words, either you are in the norm or you are not. This notion of the ideal or norm takes its cue from statistics. Davis noted the contributions made by French statistician Adolphe Quetelet (1796–1847) in his study of norms. He proposed the *law of error*, which is used by astronomers to pinpoint a star and plot all of its sightings, and then average out the errors. With this original concept in mind, Quetelet and others searched for the average attributes of humans, such as height and weight, with the intention of defining the average man, *"l'homme moyen"* (p. 2). This creation of a standard into which human beings could be fitted was a new way of thinking about the physical body. As Davis (2013) wrote, "The concept of the norm, unlike that of an ideal, implies that the majority of the population must or should be somehow be part of the norm" (p. 3).

Clapton and Fitzgerald (1997) also maintained that where one fits into society is determined by the differences found within the body. They discussed the term *Other* as those who deviate from a socially

constructed norm, and falling outside of these societal norms can lead to "isolation and abuse" (p. 1). In the Western world, past attitudes toward disability often were reflective of Judeo-Christian depictions of evil spirits, the devil, or the performance of witchcraft, which went against the ideals of God. McRuer (2006) pointed out that

> there is (literally) no way of articulating the very word "disability" in the absence of "ability"—and indeed, in the absence of mastery that, as most would have it, naturally attends able-bodiedness. And to carry these points further, there is likewise no way of saying "disabled" without hearing "cripple" (or freak, or retard as its echo). (p. 141)

Negative connotations and poor understanding of disability on the part of able-bodied individuals lead to unfair representations and misconceptions about what it actually means to live with a disability. Thus, an examination of the etymology of the word *handicap* is important before looking further at the medical and social models of disability, since this word has helped to create so much negativity and misinterpretation. In *Chambers Dictionary of Etymology* (1988), the first signs of the word *handicap* as a noun were present around the 17th century. As a verb, *handicap* was being used around 1850. *Handicap* as a verb was associated with horse racing—horses were proportionately weighted according to their known abilities to equalize the chances of all horses winning the race. However, this weighting also created an unfair advantage for all the horses, since it was more difficult for any of them to win. The word *handicap* did not have a negative association until 1915 when much debate surfaced around cases such as Baby Bollinger, a child born with severe physical deficits in Chicago at the American-German hospital. The infant was not given assistance to survive because the physician, Dr. Haiselden, thought it would be better for him to die rather than live with the condition with which he was born. His death sparked a major controversy regarding eugenics (Pernick, 1996).

Another aspect of "handicapism" is that individuals are expected to try to overcome their obstacles (similarly to that of the weighted horse in the race). Thus, it is important to discuss two different models of understanding disability: the medical model and the social model. Many

progressive theorists have elaborated on or redefined the original terminology associated with the social model of disability. I still felt it important to incorporate the original characteristics of the social model, since it has catapulted a movement toward the study of the issues of fairness and equality as they apply to disability. Both models illustrate, in different ways, how stereotypes are perpetuated by society and restrict the growth of individuals living with disability (Shakespeare & Watson, 2002).

Medical Model vs. Social Model. Originating in the United Kingdom in the 1980s, the medical and social models of disability were used to understand interpretations of disability. Generally, the medical model is a negative view of disability that blames the individual for not being able to overcome his or her disability. This model supports a sociopolitical agenda based on the World Health Organization (1980) criteria that grouped all disabilities into one category and put the onus on the person with a disability to find a way to adapt to social norms.

The social model of disability was developed by Michael Oliver (1983) in response to the narrow connotations associated with the medical model. According to Oliver (1990), the social model sought to create a paradigm shift that acknowledged that individuals living with disability have differences to which society can adapt. For example, society can adapt to these differences by constructing wheelchair ramps at the entrances of buildings or by extending the time to write an exam for individuals with a visual impairment or learning deficit. Oliver (1990) also argues that the social model strives to break the cycle of doctors and other professionals who try to "normalize" or deny individuals living with disability by treating their disability as something that should be cured rather than accepted. Unfortunately, researchers in the field of critical disability studies in education agree that the medical model is emphasized far more than the social model (Doob, 1994; Gabel, 2006; Sandahl & Auslander, 2005). Sandahl and Auslander (2005), for example, are critical of the medical model because they are concerned with the way it situates the disabled population as "patients" who should be "infantized," "pathologized," and "disempowered" (p. 129).

Doob (1994) discussed the distinct lack of an "ism" to describe the process of disability in the same way that "sexism" or "ageism" is used (p. 290). Using a sociological lens, Doob refers to the five prejudices that characterize society's view of disability and to individuals referred to as "other" from the norm. First is the negative reaction of people when they see physical traits that are outside the norm (Gabel, 2001; Johnstone, 2004; Shapiro, 1993). Often, these kinds of reactions are linked with the misconceptions and low tolerance of individuals when thinking about physical disabilities. According to Doob (1994), a second prejudice is the assumption that certain characteristics can be ascribed to those living with a disability. Labeled as both "different" and "inferior," similar to other minorities, those with a disability are plagued with stereotypes that lack substantial support. This stereotypical labeling of disability can be directed toward the social model of disability as it is created and perpetuated by society's preconceived notions of what it means to be disabled. A third prejudice involves the justification of discrimination toward the disabled community. The differences between those living with disability and those who are not raise questions about fairness and punishment. Disability is seen as a problem without remedy, which encourages an attitude that it would be better to get rid of those individuals who are not able to take care of themselves. According to Doob (1994), in the 19th and 20th centuries, "many crimes, delinquencies, poverty, and immorality were linked to disabled persons; however, this attitude has shifted since the ADA was implemented in 1990 (p. 291). The fourth prejudice is how those living with disability, similar to other minorities, are forced to adapt to the majority. In other words, the disabled must find ways to acclimate into the mainstream. As Doob (1994) writes, "the blind, for instance, frequently recognize that they are likely to receive greater acceptance if they consider the visual dimension when dealing with sighted people" (p. 291). The fifth prejudice involves the large range of discrimination (associated with attitudes, architecture, education, occupation, transportation, and housing) that affects the disabled community. The main goal of the ADA was to help create more opportunities and equality for the disabled community. After the ADA was passed, more opportunities were opened up for employment, public

accommodations, services from the state and local government, and advancements in telecommunications; however, resistance to accepting disability still exists.

Doob (1994) clearly outlined the various ways in which discrimination plays a vital role in the perception of *disability*. Gabel (2005/2009) adds:

> To regard disability as a social construction or creation is not to deny human variation. Human beings suffer in many ways. Variations according to ability do not need to be valued negatively or wrapped in stereotypes and stigma. Disability is not viewed as a social condition to be cured but rather as a difference to be accepted and accommodated. It is a social phenomena through and through. (pp. xix–xx)

Theorists in the field of CDSE (Gabel, 2005/2009; Roper, 2003) continually highlight the stereotypes and stigmas associated with individuals who have some form of disability. As a result of these stereotypes and stigmas, it is crucial to discuss the emergence of the disabling term *handicap* and how it is so often confused with the term *disability*. Similar to racism and sexism, handicapism is a socially constructed concept that works to undermine, disseminate negative views, and encourage unequal treatment of individuals living with physical, mental, or behavioral differences. In essence, an individual has a disability, but it is his or her environment that stigmatizes them with the disability. In relation to the environment that leads to misconceptions about disability, I continue to question the media's role in perpetuating these stereotypes, since media is *the* outlet that reaches millions of people worldwide (Gabel & Connor, 2009).

Often, it is difficult and perplexing to work in the field of critical disability studies in education, since disability is a growing educational discipline that attracts controversy due to its representation in mainstream society. Writing from the perspective of a "non-disabled" person also complicates the work, although I am mindful and attuned to the issues and debates facing the disabled population on a daily basis. The present study is motivated by my desire to examine the effects of television representations of the disabled in an educational context, specifically geared toward elementary and high school students, while

keeping in mind that using the media to explain various phenomena, global situations, and social attitudes toward marginalized groups is both critical and essential in present-day culture.

Disability in the Media

According to Haller (2006), "[t]he concept of handicapism, now known as ableism, is germane to the growing interest by mass communication scholars studying media representations of people with disabilities" (p. 7). Although media history scholars have become much more aware of gender and ethnicity in their work, little research has been done on the historical representation of people with disabilities in the media. Since the 1960s, the disabled and the organizations supporting those living with disability have brought to light the discriminatory nature of the disabled image (Clogston, 1992; Haller, 2006).

Negative representations of people with disabilities date back to classical Greek theater in which disabled individuals were depicted as evil and corrupt beings who were unable to perform sexually and who posed a threat to the non-disabled population. In older works of fiction, characters such as Tiny Tim in Charles Dickens's *A Christmas Carol* (1843) and Clara in Johanna Spyri's *Heidi* (1899) have been portrayed as inept, needy, and insufficient. There are many other wicked characters in children's novels, such as Captain Hook in J. M. Barrie's *Peter Pan* (Dowker, 2004). The imagery created by the disabled characters profiled in literature perpetuates feelings of sorrow and disdain, leaving an audience with a view of disability laced with pity or apprehension (Barnes, 1996; Shapiro, 1999).

With the growth of television over the last 50 years, the negative representation of disability was extended to a new media. Often, characters who have disabilities on television and in film are demonized (Roper, 2003). An example of this negative representation can be found in the television show and the film *Wild, Wild West* (1965–1969). In the television series, Dr. Arliss Loveless, a villainous doctor, is a dwarf, and in the 1999 movie, the doctor's character is in a wheelchair and missing half of his body. However, more contemporary representations of disability on television (e.g., *Glee, Breaking Bad, Parenthood*) seem to be

normalizing disabilities and giving characters more significant roles. As Longmore (2003) writes:

> Giving disabilities to villainous characters reflects and reinforces, albeit in exaggerated fashion, three common prejudices against handicapped people: disability is a punishment for evil; disabled people are embittered by their "fate"; disabled people resent the nondisabled and would, if they could, destroy them. (p. 134)

These common attributes of disability portraying villains and evil are used to perpetuate the notion that disability is negative and unappealing. These images are powerful and do not allow for an advancement of positive representation.

Gardner and Radel (1978) were some of the earlier researchers who analyzed American newspapers and television for their representations of disabled people. A lot of what they found depicted individuals with disability as dependent, not contributing to society, and awkward. The distorted nature of these images can influence an individual's perceptions of self by creating a negative stigma of disability. Likewise, added para, 11 (online journal) notes:

> Although there are no specific data showing attitude change in response to media communication, people tend to believe that the manner in which characters are portrayed is important. Characters presented on screen are sociocultural stereotypes designed to appeal to the majority of viewers, and reflect widely held values (albeit mostly American). It seems apparent that the repeated presentation of images in an acceptable and palatable manner will result in those images becoming a typification of everyday existence. The media are efficient in implanting new information and contributing new ideas and values, where they are not in conflict with strongly held views creating an "Average" typification of the disabled (para, 11).

As Dahl suggests, the repetition of negative images becomes a mainstay for what is acceptable and believed to be accurate.

Barnes (1996) also discusses the tendency of media to depict disability through telethons to raise money for a cause, although in recent years, disability has been increasingly seen as important to address as other marginalized groups, such as non-whites, gay/lesbian/transgender persons, and women.

Clogston (1990) and Shakespeare (1999) developed a useful model for describing the cyclical themes relating to disability in the news media. For example, Shakespeare (as cited in Haller, 2006) specifically made a strong case for the language used in the news as having the potential to empower or stigmatize individuals living with disabilities. Although this model relates to journalism and newscasts, it still is useful for categorizing the recurring themes that appear on broadcast television programs. Clogston's (1990) model has two main categories—traditional and progressive—and each category includes several models:

Traditional

- Medical model*
- Social pathology model*
- Supercrip model*
- Business model*
*More detailed explanations and examples appear below.

Progressive

- Minority/civil rights model
- Legal model
- Cultural pluralism model consumer model

The **medical model** presents disability as an illness or disease. Those who are living with disability are looked at negatively because they are thought to depend on health professionals for a cure or control of their weaknesses. People with disabilities are seen as unable to participate in the same activities and everyday routines considered "normal" by mainstream society. The perception becomes that individuals living with disability are looking to cure their impairment or that they have to turn toward others for support (Hahn, 2010).

The **social pathology model** sees disability as a hindrance on society because of the economic requirements and adjustments necessary to accommodate people with disabilities. Thus, disability is perceived as a burden or an inconvenience. In a school setting, for example, this might mean bringing in inclusive programs and/or making proper

adjustments to accommodate various learning and physical differences (i.e., wheelchair ramps, educational assistants, visual aids, individualized education plans, etc.) (Clogston, 1990).

The **supercrip model** positions people with disabilities as abnormal because they have to perform everyday tasks with limited ability. This particular model often is found in movies, television programs, and literature. An example of this view is reflected in the movie *Daredevil* in which the main character, Matt Murdoch, is blinded by a radioactive substance and then turns into a superhero by using his now-heightened other senses (Clogston, 1993).

Like the social pathology model, the **business model** deals with the high costs of disability to society because of the requirements for more accessibility to create accommodations. An example of this view would be a department store that does not accommodate individuals who require a wheelchair access ramp because it is a too costly and they consider it an unnecessary expense (Haller, 1995).

The progressive category includes models that are a clear contrast to those of the traditional category. For example, the **minority/civil rights model** argues that people with disabilities are entitled to civil rights, which include the adaptations that society must make to accommodate their differences. In essence, this perspective supports the rights of individuals to live their lives independently and confidently without supervision from others (Clogston, 1990).

The **legal model**, associated with the ADA of 1990, implements the legal rights and protections of individuals with disabilities against unjust treatment and discrimination (Haller, 1995).

The **cultural pluralism model** recognizes the many talents and contributions that disabled individuals make to society. This model makes an effort to not differentiate between disabled and non-disabled people (Clogston, 1990).

The **consumer model** aims to create more accessibility so that disabled individuals can access a wider array of jobs and become more self-sufficient and thus not need as much government assistance. Access to a wide diversity of jobs is important because people living with disability are consumers and contribute to the growth of the economy (Haller, 1995).

Conclusion

Clogston's and Haller's traditional and progressive categories of disability in the media have helped shape the theoretical framework for my research into images of the disabled on television. While representations of disability in the mainstream media are still few and far between, within the last six years, primetime television programs have been more inclusive of this population. Moreover, in general, the depictions of disability on television have begun to shift toward the progressive models in an attempt to move away from stereotypical images of disabled characters.

In January 2008, the cable network AMC premiered the TV series *Breaking Bad*, which features a teenage boy with cerebral palsy who uses crutches and has slurred speech. In 2009, two new television series were broadcast on network television—*Glee* (Fox) and *Parenthood* (NBC)—which deal with youth and disability (not something often seen on network television). *Glee*, in particular, has become a pop-culture phenomenon and has managed to change the face of television with its emphasis on differences and the positive impact that arts education can have on those living with disability. *Parenthood* follows one family's realization that their child has autism spectrum disorder and the daily struggles that the parents go through to cope with this diagnosis. The significance of these shows is reflected in the high ratings they receive and their ability to attract large audiences. I analyze these three network TV series in Chapter 6. I also historicize television in my study and discuss the evolving role of television programs with respect to representation, the shift in the portrayals of characters with disability, the greater frequency by which characters with disability (youth specifically, 9–18 years old) are now featured, and the emerging storylines in both dramas and situational comedies that include progressive portrayals of persons living with disability.

What Do Popular Culture, Television, and Youth Have to Do with It?

Few subjects range as far and vary as frequently as does popular culture. It seems to embrace all and to discard much. Its consistency is change. Like the escalator that is now so essential to the shopping center, sports arena and airport, it moves regularly, conveying us all up and down to different levels of engagement and distraction, to goods and pleasures regularly arranged to attract, to appeal, to entice. (Betts, 2004, Preface)

Historical Overview

Patterns of television viewing and practices have changed dramatically over the last 60 years. To better understand this trend, I begin this section with a working definition of *popular culture*. In academia, the debate over the validity of the concept of popular culture continues. For example, some researchers of popular culture (Steinberg & Kincheloe, 2004) have argued that it reflects the attitudes of the younger generation, and we need to include it in educational forums (i.e., the school

curriculum, everyday interactions between teacher/student), whereas others (for example, Storey, 2001) have pointed out that popular culture is the residue of what is left over from "high culture" or what is considered well renowned by the upper classes of society (those individuals with wealth, distinction, and power) with respect to art, music, film, and literature. Nevertheless, in the past 30 years, the study of popular culture has evolved to become a critical part of cultural and media studies. According to Betts (2004), the rise of popular culture began after World War II, and Richardson (2012) suggests that this growth developed in a dramatically changing economy and social standards that created a division between the older and younger generations. Americans obtained much of their information about the war and other events from the radio. War movies and cartoons generated more widespread messages and created standards as they appealed to larger audiences. As men started coming back from the war, goods were being produced again for consumption, ideologies changed, and the population started to boom.

Rosenblum (1981) has pointed out that "Popular culture has been accepted in much of the academic world as a valid reflection of a form of cultural pluralism in which many different kinds of cultures are expressing their values through various popular art forms" (p. 8). So it is important to keep in mind that *popular culture* is a virtual "melting pot" of ideas with many contradictory points of view that make it difficult to pinpoint one clear and concise definition.

Storey (2001), however, unpacked the term *popular culture* by focusing on the terms *culture* and *ideology* to better understand the complex nature of popular culture in contemporary society. Storey defined *culture* as something that is well received or liked by a group of individuals. Steinberg (2006), another theorist of popular culture, defined *culture* as the behavior patterns socially acquired and transmitted by the use of social symbols: language arts, science, morals, values, belief systems, and politics. This notion of *culture* as a universal means through which individuals experience activities and practices in their daily lives is central to the understanding of culture as it pertains to the wider/dominant theory of popular culture. Storey (2001) defines *ideology* as an organized group of ideas expressed by a particular

group of people. *Ideology* differs from *popular culture* because ideology is based on "lived experience," which includes the relationships between individuals and commodities or material things (Hebdige, 1979). In relation to disability, Oliver (1990) believes *ideology* to be a set of values and beliefs affecting social practices; many of the beliefs regarding disability are linked with dominant ideological perceptions that disability is medical and tragic, and therefore they attempt to normalize the disabled. Gramsci (1971) also discusses this:

> One must distinguish between historically organic ideologies, those, that is, which are necessary to a given structure, and ideologies that are arbitrary, rationalistic, or "willed." To the extent that ideologies are historically necessary they have a validity which is "psychological"; they "organize" human masses, and create the terrain on which men move, acquire consciousness of their position, struggle, etc. To the extent that they are arbitrary they only create individual "movements," polemics and so on. (p. 377)

These definitions of *ideology* all work together to conceptualize the notion of dominant culture. They are based on the majority's interests and work to motivate and structure areas of society. Disability is situated as a problem best resolved through the market and collective access to consumption.

In contrast, popular culture is constantly changing to appeal to a fast-paced, technically driven, mainstream culture of individuals. Storey (2001) has suggested that *popular culture* is that which is "left over after we have decided what is high culture" (p. 6). Many arguments have been made by cultural theorists about the blurred lines between high and low cultures. For example, Bourdieu (1984) argued that society incorporates "symbolic goods, especially those regarded as the attributes of excellence... [as] the ideal weapon in strategies of distinction" (p. 59). He also identified several variables—economic, cultural, and social capital—that help determine a person's class position in society. A particular group may be more invested in one of these variables, which may destabilize the social structure. Bourdieu's work supports the theory of high and low cultures blurring together because an individual's taste separates the cultures into what is considered high and low (i.e., a piece of art, film, literature, fashion) and symbolizes

what types of goods continue being produced and purchased for use. Since the 1980s, academics of popular culture such as Stuart Hall (1981) argued that our critiques of "the popular" be taken with careful consideration of the importance of production, consumption, and social experience to the discipline. When limiting our understandings of popular culture to modifications of mass production, like Adorno and Horkheimer (1972) did, or to see the actions of consumption as completely empowering, like John Fiske (1989), ignores the physical space and specific historical circumstances of popular culture and its ability as a basis of political action (Bourdieu, 1984; Brottman, 2005).

Considering how contemporary popular culture seems to dominate how individuals obtain information and view each other, Husserl's (1913/1982) concept of *natural attitude* may help provide some insight into why popular culture is so powerful: "The natural attitude is our ordinary way of approaching experience which assumes an established realm of objectivity, intersubjectivity, and selfhood" (Carroll & Tafoya, 2000, p. 6). In other words, simplistic, everyday events set the implicit need for phenomenology to be a part of popular culture. At times, though, these common occurrences are overlooked by individuals because they have become routine. Standards and norms go unquestioned and overlooked. In *Doing Educational Research*, Tobin and Kincheloe (2006) suggest that

> Humans come to be who they are and change who they are as a result of their interrelationships, their connections to the social sphere. They learn to think and talk via socially constructed languages, deport themselves via cultural norms in their communities, and take care of themselves by imitating significant others in their immediate environment. (p. 6)

Many theories exist that support the notion that popular culture influences society (e.g., Kellner, 1995; McLuhan, 1967; Postman, 1985; Steinberg & Macedo, 2007). Briefly, McLuhan illustrates the media as a tool seeking to deliver a message to and about society in an impactful way. Postman suggests that modern technology and media are significant at influencing our ideologies and beliefs but cannot replace the importance of human values. Kellner argues the products of media

culture (e.g., film, television, music, Internet, literature) and how these in turn influence the identity formation of "us" versus "them." Finally, Steinberg discusses the role of marketing and advertising toward children and how greatly this influences developing values and ideologies. Thus, the perception of how certain groups are represented as reflections of the mainstream public view of these groups raises important issues about the role of popular culture in society. For example, Talbot (2007) stated:

> The importance of the media in the modern world is incontrovertible. For some sections of society, at least, the media have largely replaced older institutions (such as the Church, or trade unions) as the primary source of understanding of the world. (p. 3)

Postman (1985) also has highlighted the complexity of the role of media:

> for there are times when it lags slightly behind, times when it anticipates changes, times when it is precisely on target. But it could never afford to be off the mark by too great a margin or it ceases to be a popular art. (p. 126)

Inundated by media, society has almost taken for granted the accuracy of media, never analyzing or questioning its veracity. Therefore, media often have gotten a free pass when it comes to validating "facts," as most Americans gather different types of information from news broadcasts, radio, social media, and various websites from the Internet (http://www.gallup.com/poll/163412/americans-main-source-news.aspx). This lack of responsibility to be truthful has led to an oversaturation of media images in our daily lives and a pessimism about popular culture, which has desensitized us and encouraged us to behave like non-thinking drones. Media culture influences our values and ideas of class, race, gender, ability, and sexuality; it influences our identities and our perceived places in the social world (Kellner, 1995).

While considering the negative connotations of popular culture, it also is important to study the theoretical frameworks that take a more positive view of popular culture. For example, Johnson (2006) argued that popular culture is not "dumbing us down," since "[t]he last thirty years of popular culture is the story of rising complexity

and increased cognitive demands, an ascent that runs nicely parallel to—and may well explain—the upward track of our IQ scores" (p. 184). The video games that children play, the plot lines of contemporary television programs and films, and contemporary works of fiction all contribute to creating a faster-paced and more technically savvy environment, which appears to be making us smarter rather than dumber. Nevertheless, subsequent aspects of our life experience have been compromised. Some examples of this decline are the decreasing social interactions between individuals and an overabundance of packaged "reality" shows that some claim reflect the true nature of contemporary popular culture. Johnson (2006) seems to justify children's obsessions with media as part of a growing set of cognitive skills that are creating more interpersonal connections because of the complex narratives of the media storylines (pp. 98–99). In contrast to the many media theorists and experts on culture who consider popular culture to be "low" and thoughtless, Johnson offers a worthwhile and provocative perspective.

Once called the "high priest of pop-culture" (see McLuhan, 1995), Marshall McLuhan (1967) has done an uncanny job of connecting the media and technology to cultural studies and has highlighted the powerful impact of media and technology on representation, identity, and culture. McLuhan's analysis of the value shifts reflected by popular culture has paved the way for many media and cultural studies theories: "Societies have always been shaped more by the nature of the media by which men communicate than by the content of communication" (McLuhan, 1967, p. 8). McLuhan's keen eye for reading the effects of media on our daily experiences has revolutionized the way media scholars understand how media shape our ideals and views.

The theory of popular culture that most closely resembles the research on individuals with a disability is Talbot's (2007) theory of media as a "primary source of understanding the world" (p. 126). This theory highlights a central point of my argument about how the media powerfully shapes the ideologies circulating in society through the images and language that are used daily to represent (both positively and negatively) individuals living with disability.

The Strong Hold of Media on Our Psyche

Marshall McLuhan was a pioneer in media studies and in making sense of the worldwide technology boom. For example, he examined the ways that media expose us and position us to perceive various groups and demographics that we may never have been able to without its technological access. In *Understanding Media: The Extension of Man* (1964), McLuhan states:

> Electric speed in bringing all social and political functions together in a sudden implosion has heightened human awareness of responsibility to an intense degree. It is this implosive factor that alters the position of the Negro, the teen-ager, and some other groups. They can no longer be *contained*, in the political sense of limited association. They are now *involved* in our lives, as we in theirs, thanks to the electric media. (p. 5)

McLuhan's thought was deeply rooted in anthropology, and he used the terms of this discipline to describe the connection of society to technology: "The unrivaled power of TV" helps unify "an entire population in a ritual process" (McLuhan, 1967/1994, p. 336). He also spoke of television programs as belonging to an electronic "tribe" and thought that the media collected information in a "hunter-gatherer"-like fashion (Merrin, 2005).

McLuhan called media an "extension of man," meaning that media and communication technology has allowed people to experience never-before-experienced situations and gain a greater access to and control of information, which has undermined our ability to understand and process the wealth of information that travels at ever-faster speeds. McLuhan also developed an important tool for understanding media—his concept of "hot" and "cool" media, referring to the different sensory effects of higher and lower definitions. High-definition ("hot") media, such as print or radio, are full of information but allow less sensory completion or involvement on the part of the reader or listener than low-definition ("cool") media, such as the telephone or television, which are relatively lacking in information but require a higher sensory involvement from the user (McLuhan, 1964). McLuhan's provocative

theories, made in the early 1960s, are timeless and help us maintain a critical eye toward contemporary media.

McLuhan also has attracted some negative criticism for his work. For example, Baudrillard argued that McLuhan failed to consider the "historical and social context in his work on media and for 'fundamental determinism,' 'technological idealism' and 'optimism'" (Merrin, 2005, p. 49). Thus, the endless debate over a proper definition for *media* continues.

Representation

In general, *representation* refers to the creation—in any medium, especially mass media—of aspects of "reality" such as people, places, objects, events, cultural identities, and other abstract concepts. I have drawn primarily on the theoretical frameworks of Hall (2006) and du Gay (1997) to clarify and elaborate what is recognized as representation. According to Hall (2006), *representation* has a variety of interpretations. With respect to groups—for example, those living with a disability—to be represented is to have someone "depict" or "stand in" for a particular group. Specifically, Hall described *representation* as an act of re-presenting a meaning that already exists, as the way by which meaning is depicted by images and words that stand for something else. These representations may be in speech or writing or as still or moving pictures. Another significant aspect of representation is perception, which relates to how an audience takes in the images produced, through which meaning is filtered. Hall's theory of representation involves three key approaches: the *reflective*, *intentional*, and *constructionist*. The *reflective approach* considers how representation mirrors an object, place, person, or event already existing in the world (Hall, 2006, p. 25). The *intentional approach* deals with language's impact on making meaning. In other words, the person speaking conveys his or her intent by choosing the appropriate language to fit what is being depicted (Hall, 2006). Last, the *constructionist approach* looks at language as something socially constructed by individuals. Society creates systems to represent certain concepts and signs. For instance, the reflective approach considers

how individuals have an opportunity to take in the meaning intended from a given object. With respect to disability, an able-bodied person may view a wheelchair user as having a deficit because the wheelchair represents and is reflective of the disability. The intentional approach considers the use of intended language. Associating individuals living with disability as incapable, handicapped, or dependent on others perpetuates the negative connotations associated with disability. Last, the constructivist approach suggests that society constructs meaning through signs and systems. For example, a sign for a parking spot reserved for a "handicapped" person is a socially constructed symbol that makes disability visually representable and identifiable to the mainstream population. The application of these concepts to an overall understanding of representation is important, especially in regard to media studies, because they put so much emphasis on how certain groups are represented (Hall, 2006, 2008).

The identities represented in the media, and especially in television, have major implications for the audience. For instance, the portrayal of an African American man selling drugs and involved in a violent gang takes on a different meaning in a low-income area of the Bronx, New York, than it would in an upper-middle-class neighbourhood of Westchester, New York, because of the different experiences of the audience. These are examples that show how identities and their subsequent representations are contextualized and influenced by political and cultural discourses. Identities are entwined in relations of power and are the product of distinguishing between difference and sameness (Hall, 1996). Hall (1999) goes on to say,

> identity as contradictory, as composed of more than one discourse, as composed always across the silences of the other, as written in and through ambivalence and desire... [rather than] a sealed or closed totality. (p. 148)

This relates to the relationships between ability and (dis)ability, as there are differentiating factors that work to exclude individuals that fall out of societal norms.

With regard to the audience's interpretation of media content in relation to the hierarchical structure of society, Mittell (2004) states,

"The goal of most cultural media scholarship is not to understand the media in and of themselves, but rather to look at the workings of media as a component of social contexts and power relations" (p. 178). As du Gay, Hall, Janes, Mackay, and Negus (1997) argue, meaning comes from representations by means of language, photography, painting, and other media that use "signs and symbols to represent or re-present whatever exists in the world in terms of a meaningful concept, image or idea" (p. 13). Much of what we have come to know regarding the formation of identity comes from representation and the perceived notions of others (Hall, 1996). The effect of mediated images on society can be transformative for identity formation. To complement the theories of representation and culture, du Gay et al. (1997) developed the "Circuit of Culture" that describes a "whole way of life" (p. 13). They argued that culture is a production composed of many different meanings.

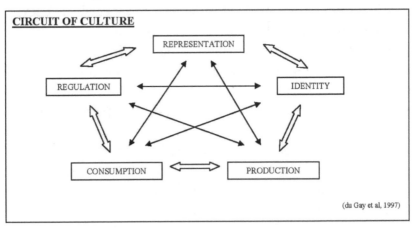

Figure 3.1: Circuit of Culture (du Gay, Hall, Janes, Mackay, & Negus, 1997).

In essence, the Circuit of Culture suggests that the elements of representation cannot be understood in isolation. The five components in the circuit are as follows:

1) **Representation**: The use of such things as language, photography, painting, and other media that use "signs and symbols to represent or re-present whatever exists in the world in terms of a meaningful concept, image or idea" (du Gay et al., 1997, p. 13).

2) **Identity**: How meaning is constructed and internalized by the individual person or cultural group when confronted with a text (du Gay et al., 1997).

3) **Regulation**: The attempt to codify, or manipulate in some way, practices related to the other processes of the circuit of culture. Regulation often is the goal of those with the power to fix meanings in ways they deem desirable.

4) **Consumption**: When individuals, groups, and/or corporations compete to have their identities consumed or interpreted by society to successfully put out and sell their product. Du Gay et al. (1997) note that:

> Through consumption we are urged to shape our lives through our purchasing powers. We are obliged to make our lives meaningful by selecting our personal lifestyle from those offered to us in advertising, soap operas, and films, to make sense of our existence by exercising our freedom to choose in a market in which one simultaneously purchases products and services, and assembles, manages, and markets oneself. (p. 309)

This strategy is not always successful, since people possess interpretive systems that they impose on the interpretation of the representations of others.

5) **Production**: The mass-produced images and sounds that are created by various artists, novelists, and musicians, which, in turn, are consumed as an expected "standardized" outcome at the end (du Gay et al., 1997).

These five elements are crucial with respect to the overall framework of culture and representation and to the perpetuation of certain myths and misconceptions regarding disability. As du Gay's theory notes, the meaning attached to disability is socially constructed, and it picks up on different notions of what it means to be disabled, handicapped, or impaired. The theory relating to the Circuit of Culture is central to disability and representation. Representation is a reflective process in which concepts are constructed and then deconstructed, which leads to an endless flow of exchange, questioning of ideas, beliefs, and cultural norms.

Conclusion

In this chapter, I looked primarily at Postman's (1985), Kellner's (1995), Storey's (2001), and Steinberg and Kincheloe's (2004) concepts and discussed the history of popular and dominant media culture, along with the theories surrounding its influence on identity formation. It was important to synthesize the work of Marshall McLuhan (1967), as he was one of the pioneers interested in developing media theory. I also focused on representation and identity using du Gay's and Hall's (1996, 1997, 2008) frameworks on some of the central elements making up this structure. Included in this was the Circuit of Culture, which works to represent the flow of everyday culture and pinpoint the areas that are most focused in the overall social milieu. In this analysis, it is vital to include research that suggests the way disability intersects with other identity categories as complex and subject to various social, cultural, and political contexts. In the next chapter, I examine media, culture, and ideology in the context of education. This focus is critical for developing my thesis because of the power that images in mainstream media have on youth and their attitudes.

Youth Is Wasted on the Young and Other Myths About Popular Culture

Today's consumers are watching more TV than ever, which makes understanding what and how they are watching an essential part of any marketing campaign. (Nielsen Media Research, 2012)

Television differs from all other media preceding it in that it reaches children at a much earlier age and with greater intensity. This enhanced potential for influencing the intellectual and emotional development of young viewers is simultaneously the greatest promise and greatest disappointment of television (Berry & Asamen, 1993).

The debate has been ongoing regarding the importance of including media as a tool for teaching in our schools. That said, notions about how to properly use media are loaded with misconceptions and false perceptions. Our understanding of media and its implications and uses for education has grown significantly over the last decade. This new awareness has been informed by critical theorists such as Steinberg (2011), Kellner and Share (2007), and Kincheloe (2005b), who looked at how education has evolved into a more technological and popular culture–based discourse. They compared and contrasted past approaches to education and schooling and found an

undeniable need for a media-based curriculum to help establish critical thinking and opportunities for success in the workplace. For example, Kincheloe (2005b) argued that information is dispersed from corporate-dominated producers to those who are non-privileged or considered to be a minority or disenfranchised. Kincheloe argued, "In our critical interpretive context, the notion of cultural pedagogy asserts that the new 'educators' in the electronically wired contemporary era are those who possess the financial resources to use mass media" (p. 59).

Overwhelming access to information plays a large role in determining what is relevant and worthy of consumption. In the field of cultural studies, Steinberg (2007) has written about the unavoidable path that mass media has taken and how it has influenced the way individuals see the world. A major focus of cultural studies is to acknowledge all forms of culture and therefore blur the line between what might be considered high culture and low culture, which brings all aspects of popular culture together. A greater awareness of culture is critical for educating youth today because of the prevalence of media and technology in their lives. Jenkins (2006) studied participation from the audience in featured media content across different cultures and found that when an audience actively participates in the production of media, the media remain competitive, and the information they produce stays relevant and noteworthy; thus, a wider audience takes interest in what is considered current at the time (Steinberg, 2004).

When considering how to safely and effectively teach with media, parents, educators, and administrators face a whole new set of challenges. Kellner and Share (2007) have suggested that

> [i]n the interest of a vibrant participatory democracy, educators need to move the discourse beyond the stage of debating whether or not critical media literacy should be taught, and instead focus energy and resources on exploring the best ways to implement it.

The critical study of media can help students understand stereotyping, authoritarian ideals, politics, and other global issues (Kellner & Share, 2007). Implementing this critical approach to media in the curriculum

is a constructivist strategy for teaching youth that emphasizes the social construction of meaning, which is important for examining media representations of youth living with disabilities. In *Teaching as a Conserving Activity* (1979), Postman argued,

> In a medium in which the image captures most attention, personality supersedes—in fact, all but obliterates—ideas and issues. That is why one becomes a celebrity by the mere fact of appearing on television. No prior accomplishment is required. Nor a reason for being there. It is accomplishment enough for one's image to be on television. It is its own reason. In such a situation, individualism takes on a wholly different aspect from its meaning in a book culture. The individualism of the book leads to the dominance of the mind. The individualism of TV leads to the dominance of personality. (p. 66)

As Postman suggests, the effects of media on children, adolescents, and adults are influential. It is clear that media producers and power brokers leave a lasting impact on our psyches. With respect to education especially, the impact of media on youth and how they learn from media are crucial concerns of parents, administrators, and educators. Thus, it is important to next clarify the demographic at the center of this debate—youth.

What's Youth Got to Do with It?

Defining the terms *youth* and more specifically *youth with disability* is important when identifying an age group that is so widely affected by media and popular culture (i.e., culture that involves television, music, film, Internet, books). Steinberg (2011) pointed out that the notion of youth or "teenager" did not hold much significance for the older generation until the late 20th century. In the earlier part of the 20th century, the lines between adult and youth were blurred by lack of education, and many young people were forced to work at a young age. In the 1960s, a revolution of popular culture was on the rise. For example, bands such as the Beatles and Rolling Stones and rebels such as James Dean and Elvis Presley inspired a widening gulf between the cultures and interests of teenagers and adults (Steinberg, 2011).

The foundations of education theory are based on the work of Piaget (b. 1896), Freud (b. 1856), and Vygotsky (b. 1896), who all examined the different stages of development of children and adolescents. Whereas Piaget (1896) identified *youth* as involving developmental stages beginning around 12 years of age, including an ability to conceptualize, understand concepts, and build relationships, Steinberg (2012) interprets *youth* as meaning adolescents ranging in age between 11 and 21—moreover, *youth* is a term that is "culturally and socially defined by the surroundings and experience of each young adult" (p. 273). Steinberg's notions of youth work better in a postmodernist era in which the rapid growth of technology and media and the complexities of cultural differences substantially affect adolescent development. Steinberg also pointed out that adults' references to "older kids" or "teenagers" first appeared in the literature of the late 1930s and 1940s.

For the purposes of my study, *youth with disability* refers to a particular population of individuals represented in media. The website www.census.gov reports that in 2010, about 2.8 million (5.2 percent) of the 53.9 million school-aged children (ages 5 to 17) in the U.S. civilian non-institutionalized population had a disability. Several organizations and policies—for example, the United Nations: Youth Social Policy and Development Division [1] the United States Department of Health and Human Services,[2] and Americans with Disabilities Act[3]—have been established to assist youth living with disability, but many problem areas still exist, such as unfair representation in media, lack of economic opportunities, and accessibility. Thus, in the following paragraphs, I continue to examine the theories about how media attract youth as an audience and the relationship of critical media education and child and adolescent development.

Kellner (2003a) stated that "[p]opular television articulates in allegorical forms the fears, fantasies and dreams of a given society at a particular point in time" (p. 50). His study examined the way that popular TV allows for greater access to social problems and how it functions as a platform in which everyday issues and concerns are articulated. The appeal of TV's and broadcasters' ability to reach multitudes of young adults (ages 15–25) has encouraged writers, producers, and advertisers to tailor television for this demographic. It is essential, therefore, to ask

who is producing the media that becomes such an important part of popular culture. Thus, Halloran (1981) suggested, "If broadcasters are unable to find a way of speaking to the needs and interests of young people as the young people themselves perceive these, then there will be no communication" (p. 23). With respect to my research topic, Kellner's observation implies that the emergence of TV characters with disabilities speaks to the relatively undeveloped societal consciousness of differently abled people, which, from one perspective, can be interpreted as a positive indication of a society attempting to accommodate and accept those with disabilities.

The success or failure of any form of new media depends largely on the needs of its audience. This is especially true for television. Today, it would seem that an educational medium is easily overlooked if it does not feature an entertainment component, which raises the question of whether TV series are produced for the purposes of entertainment or for a deeper educational message. As Halloran (1981) suggested:

> It should be widely accepted now that the distinction between information and entertainment has only a limited use. Entertainment—particularly television drama—may be highly informative. In fact, it has been described as the most broadly effective educational fare in any culture, and it has been argued that all of us, whatever status or educational background, obtain much of our knowledge of the real from fictional presentations. (p. 23)

It is important to acknowledge television as a tool to teach lessons about differences and to expose audiences to a broader range of demographics. For example, when a character with Down syndrome is represented on television (e.g., *Glee*) for millions of viewers, a tone and awareness are created. The way the character is portrayed within a certain type of storyline is the purview of the creators of the show as they lay out their intention. It is undeniable that television is watched and interpreted by a large population and that this exposure starts at an early age.

Research on youth and media consumption has shown that by age three, children are active media users (Kirkorian, Wartella, & Anderson, 2008). As they grow older, the amount of time they spend watching television increases. As Postman (1985) argued:

> the major educational enterprise now being undertaken in the United States is not happening in its classrooms but in the home, in front of the television set, and under the jurisdiction not of school administrators and teachers but of network executives and entertainers. (p. 145)

Taking into account Postman's observation, television is a catalyst for children and youth to learn about their world, and it plays a vital role in how they obtain information and learn about different cultures and ways of life.

A plethora of research exists on the dynamics of the television viewing habits of younger audiences (Gebner et al., 2002). These studies have found that each group sampled watched significant amounts of television per day, but many situations exist where these numbers increase, for example, in single-parent homes, with learning or emotionally impaired children, and in minority households. The media-saturated culture in which we live directly influences educational practices and has important implications for marginalized youth culture (Sprafkin, Gadnow, & Abelman, 1992).

Cultural Pedagogy and Education through Critical Media

In this section, I begin by discussing Lev Vygotsky's (1896–1934) Zone of Proximal Development (ZPD), which is important because it complements the theories discussed earlier about teaching youth about critical concepts—like disability—through the media. The ZPD could be described as "the distance between the actual development level as determined by independent problem solving and the level of potential development as determined through problem solving under adult guidance or in collaboration with more capable peers" (Vygotsky, 1978, p. 86). Basically, it is the difference between how a learner performs with and without assistance. In many instances, students tend to model their behavior on an adult and then develop the skills to do the task on their own. In her book *Multiculturalism in Early Childhood Education in a Democracy*, Victoria Fu (2003) explained that the ZPD extends to electronic forms as well. Children are learning to use cultural tools like

language, critical thinking, and math as they pursue the use of these new forms of technology (Fu, 2003). Children already have so much access to information at their fingertips that it is crucial to keep a close eye on how to better teach them in this media-saturated environment. Kellner (2000) explores this concern more closely in his work on media literacy and pedagogy. In relation to Vygotsky and Fu's work on more student-centered learning and empowerment, media could be used as point of entry for students and give them the jump-start needed to connect to the topic/lesson.

Kellner (2000) also explored the importance of media literacy and cultural pedagogy:

> Media arts education in turn teaches students to appreciate the aesthetic qualities of media and to use various media technologies as tools of self-expression and creation. Critical media literacy, as I would advocate it, builds on these approaches, analyzing media culture as products of social production and struggle, and teaching students to be critical of media representations and discourses, but also stressing the importance of learning to use the media as modes of self-expression and social activism. (p. 387)

These tools and concepts are being continuously developed and used in the classroom as alternative possibilities for educating students. As a researcher of media discourse, Kellner's use of a critical approach to media to analyze the world around us and Vygotsky's work on the ZPD have helped me understand the implications of representation reinforced by dominant culture. Yet, as Kellner (1987) wrote, "Many radical theories of ideology have neglected the role of mass-media images and messages in the production and transmission of ideology" (p. 473). Theorists similar to Kellner support his views on the media and its ability to influence ideologies and values. As the media impacts education and learning, it is crucial to include in the overall approach of teaching students.

In *Media Knowledge: Readings in Popular Culture, Pedagogy, and Critical Citizenship*, Schwoch, White, and Reilly (1992) described *media* as "a site of perpetual pedagogy, hierarchy, status, and knowledge-as-power" (p. xvii). In other words, the pedagogy of media involves a ritualistic encoding and evaluation of representation in the

context of everyday living. They describe *critical citizenship* as the active questioning of the relationship between cultural structures and everyday life inside and outside of the classroom. These concepts are important to my study because they open a dialogue between students and educators to better grasp the differences among individuals with respect to the body/mind connection, gender, sex, religion, race, economic status, and so on.

To connect the effects of television and disability with education, it is crucial to examine popular culture and the education of children. The stranglehold of media on children is a central theme in contemporary youth culture that needs to be addressed, since media are being used to educate children both in school and at home. As learning migrates into new sociocultural and political spaces, cultural pedagogy seeks to redefine education. Acknowledging culture has become an important concept that can spin a curriculum into something relevant and interesting for students. The seemingly all-encompassing new media have influenced educators to move beyond traditional methods of teaching and embrace the world of media and communications as their pedagogies for a more productive learning environment. In the past, it was possible for parents to have more control over what images and representations came into the home, but with the development of new and powerful technologies—the Internet, smartphones, and cable television—it has become much more difficult to control the information to which children have access. To be "in the know" and current with popular culture, children crave all forms of media. By looking at the strong engagement of children with media and the implications of this attachment for education as a whole, Steinberg (2004) commented, "The change in the social positioning of children holds dramatic implications for education. As age boundaries blur, as chronological age becomes less important in shaping human abilities and role expectations, the crisis of childhood becomes the crisis of education" (p. 14). Taking Steinberg's comments into account, the need for educators and parents to more closely examine popular culture and media studies cannot be ignored as society continues to rapidly evolve, and modern youth are forced to keep up with its accelerating pace.

The Importance of Understanding the Impact of Television

Gebner et al. (2002) proposed that an individual's repetitive viewing of a TV program had an impact on overall behavior patterns and mindset. They called this *cultivation analysis,* which focuses on the consequences of long-term exposure to an entire system of messages. Gebner et al. defined *cultivation analysis* as

> the pattern of settings, casting, social typing, actions, and related outcomes that cuts across program types and viewing modes and defined the world of television. Viewers are born into that symbolic world and cannot avoid exposure to its recurrent patterns, usually many times a day. (p. 45)

With this definition in mind, it is possible to examine how the values, ideologies, and messages dispersed by media influence their audiences. Doing educational research and teaching in media studies is an alternative approach to schooling, teaching, and parenting, which can leave students craving more as they embrace the new methods and teaching styles delivered by their newly empowered educators.

These points are further emphasized in *Doing Educational Research* by Tobin and Kincheloe (2006):

> Humans come to be who they are and change who they are as a result of their interrelationships, their connections to the social sphere. They learn to think and talk via socially constructed languages, deport themselves via cultural norms in their communities, and take care of themselves by imitating significant others in their immediate environment. (p. 6)

These authors suggested that it is particularly important for academics to study and analyze popular culture and media. The representations of popular characters on television, in the movies, in Internet books, and in comics reflect what is going on in the minds of "normal" individuals. Although these characters represent extremes for the purposes of entertainment, they still embody some truths, which helps explain some of the social constructs relevant to contemporary culture.

Educating students to think critically about the media is fundamental to developing their independent thinking abilities, and since critical

thinking is evaluative in nature, it "consists essentially of judging authenticity, worth, or accuracy of something" (Beyer, 1988, p. 61). The importance of reading the media critically was brought to the surface nearly three decades ago and has since expanded into a theoretically based academic discipline worthy of further research and exploration.

Conclusion

In this chapter, I examined aspects of television viewing by children and adolescents, and I discussed the significant impact that television has on the development of ideas, understanding, and the perceptions of others. Since each student has a distinctive learning profile (e.g., Vygotsky's [1896–1934] zone of proximal development), the use of media as an instrument to "understand how cognitive tasks fit into the child's cultural activities" (Zeuli, 1986, p. 3) is a crucial part of educating students and helping them grasp ideas and concepts. I referred to studies from both media and education—Kellner (2004), Vygotsky (1987), Steinberg (2012), Postman (1985), and Gebner (1988)—to examine the benefits of educating students by using television and the impact it has on their development. In the next chapter, I discuss my choice of methodology.

Chapter Five

A Methodology to the Madness

Television plays a major pedagogical role in our homes (Steinberg & Macedo, 2007). It is both contemplative and persuasive. Due to its impact on our lives, it is crucial to understand the messages it generates on a daily/nightly basis.

In 2010, the Kaiser Family Foundation, an organization that provides useful information on national health issues, tracked the amount of television consumed by 8- to 18-year-old children/teenagers. Rideout, Foeher, and Roberts, the authors of the study, noted that

> 8–18-year-olds devote an average of 7 hours and 38 minutes (7:38) to using entertainment media across a typical day (more than 53 hours a week). And because they spend so much of that time "media multitasking" (using more than one medium at a time), they actually manage to pack a total of 10 hours and 45 minutes (10:45) worth of media content into those 7½ hours. The amount of time spent with media increased by an hour and seventeen minutes a day over the past five years, from 6:21 in 2004 to 7:38 today. And because of media multitasking, the total amount of media content consumed during that period has increased from 8:33 in 2004 to 10:45 today.

This study reflects a critical aspect of the current media climate. As the viewing audience continues to set the direction in which television programming goes, this influence helps determine what is relevant in today's culture. The three shows I have selected for my study are, in a large part, reflective of what is significant in our present-day philosophies surrounding representation of marginalized and misrepresented individuals. By using television as a mode of transmitting messages and ideologies, they work to mirror trends in popular culture and portray current topics and storylines. *Glee, Parenthood,* and *Breaking Bad* have high numbers in the television ratings. In 2012, the finale of *Breaking Bad* brought in 2.8 million viewers, its highest rating ever, a large showing for a cable network such as AMC in the adult 18–49 demographic (Nielsen Media Research, 2012). In 2012, *Glee* ranked third in the ratings for adults 18–49 with 5.43 million viewers. As of January 2013, *Parenthood* led NBC in the 10:00 p.m. time slot with 5.37 million viewers in the 18–49 adult demographic (Nielsen Media Research, 2012). I included this information in my study because it is indicative of the wide spectrum of viewership for the three shows I have chosen to analyze. It is also necessary to mention that the shows chosen for study come at a time where the political discourse surrounding disability has shifted as a result of the Americans with Disabilities Act (ADA) (1990) and representations are more widespread and thought provoking than before the ADA passed.

Out of the 131 primetime programs airing on the major cable networks (NBC, ABC, CBS, FOX, CW) and on basic cable (AMC) in 2008 and 2009, only three of them had youth (ages 9–18) with a disability in either a main or supporting role. It also is interesting to note that all three of the shows that I examine in this study premiered in the 2008–2009 seasons.

Table 5.1 is a breakdown of the shows, characters, ages, featured disabilities, and actors' real-life disability status.

Table 5.1: Breakdown of television programs featuring youth with disability

TV Show	Character	Disability/Condition	Age	Real life
Parenthood	Max Braverman	Autism spectrum disorder	8	Able-bodied
Glee	Artie Abrams	Paralysis of legs due to spinal cord injury (uses wheelchair)	16	Able-bodied
Glee	Becky Jackson	Down syndrome	16	Disabled
Breaking Bad	Walter White Jr.	Cerebral palsy (uses crutches)	17	Disabled

Both Artie Abrams from *Glee* and Walter White Jr. from *Breaking Bad*, the characters with physical impairments, are integrated fully into their classes at school, whereas Max, who has autism spectrum disorder, is integrated into his school in the beginning but eventually moves to a private school that deals specifically with children who have autism spectrum disorder.

It is not clear whether Becky, the character with Down syndrome (DS), is fully integrated into her classes at school because she is mostly shown assisting another character (Sue, the school's cheerleading coach) and participating in extracurricular activities organized by the school (i.e., cheerleading). Becky does not discuss or allude to studies and appears to "float" in and out of scenes. She is a constant reminder to Coach Sue of her own sister who had DS, and thus Sue is compassionate and kind and interacts with and speaks to Becky without any acknowledgment of her DS. In *Glee*, no mention is made of Becky's family—she acts as Sue's surrogate sister. Although Becky's character plays an important role on *Glee*, she does not enter the first season until midway through, and she is featured in three episodes: "Wheels," "The Power of Madonna," and "Home." Becky does not dwell on her DS, nor does she discuss it as a part of her identity.

Max's parents are involved in the school, since they are dealing with his autism spectrum disorder diagnosis and are trying to find the best place for their son to be educated. They are grappling with the following question: Would Max be able to fit into a mainstream school environment, or should he be placed in an alternative school better

suited to cope with the needs of a child diagnosed with autism spectrum disorder? On *Breaking Bad*, Walter Jr.'s parents also are involved in his school. Walter Jr. attends the school where his father Walter teaches. Indeed, Walter Jr.'s interaction with his parents is significant throughout the entire series. Even though no direct discussions are held about cerebral palsy, clearly his parents are keenly involved in his development. He deals with his life in an able-bodied "normalcy" as much as possible, without discussing the cerebral palsy. Walter Jr. is integrated fully into his high school society, drives a car, and insists on getting around on his own.

On *Glee*, the parents of Artie Abrams and Becky Jackson never appear and are not mentioned. Artie addresses his wheelchair life on his own, and he fantasizes that he could become a walking/dancing young man. Yet he manages to live his life to the fullest in his chair, which is constantly a part of his self-image.

Sampling and Data Collection

The television programs that I chose for my study are contemporary, primetime shows that air on the major cable networks (NBC, Fox, AMC), generally bringing in many viewers. According to the Nielsen ratings system, which measures audience size and the composition of television programs in the United States, Fox and NBC have dominated the television market, in their respective time slots, bringing in a high number of viewers on a weekly basis with shows like *Glee* (Fox).

I looked specifically at episodes featured in season one, each an hour long; the reason for this was for continuity and time. Focusing on the first season of each show allowed me the opportunity to see the evolution of the character and growth of each show as it premiers on network television. Through a thematic analysis, the major themes related to the depictions of contemporary disability emerged in these dramas. After rigorous note taking and episode viewing, I sorted through the many themes that I found. I chose the themes according to their frequency in the shows in which they appeared and their relevance to disability in educational settings. For example, is disability depicted

inclusively? Are the images of the disability stereotypical in nature? Is bullying involved, and if so, is it physical or emotional? Are the educators and schools integrated into the lives of the disabled characters, and how are they portrayed? These were the initial types of questions as I became more immersed in the analysis of the shows. I also found that these were the topics most widely discussed in the media on news programs and on social networking sites (i.e., Twitter, Facebook) (Bulkley, 2011).

Table 5.2: Nielsen ratings from May 19, 2010, for television programs analyzed (demographic 18–49 years of age)

Summary of the Nielsen Ratings Chart

Time	Network	Program	Viewer Share (Millions)
8:00 p.m.	Fox	*American Idol*	6.6
	CBS	*NCIS*	3.2
	NBC	*The Biggest Loser*	2.7
	ABC	*Dancing with the Stars* (results)	2.5
	CW	*90210* (finale)	0.8
9:00 p.m.	Fox	*Glee*	4.8
	ABC	*Lost*	4.1
	NBC	*The Biggest Loser*	3.5
	CBS	*NCIS: LA*	3.1
	CW	*Life Unexpected* (repeat)	0.4
10 p.m.	NBC	*Parenthood*	2.6
	CBS	*The Good Wife*	2.3
	ABC	*V* (finale)	2.3

Note: The top television programs in their time slot were *Glee* (Fox, 9:00 p.m.) and *Parenthood* (NBC, 10:00 p.m.).

For this analysis, it is useful to emphasize the ratings that these shows brought to the networks. The overall ratings of a television program reflect its popularity and importance to its intended audience, thus reiterating the significance of studying the particular shows I chose and their part in distributing representations of disability to a wide audience.

I concentrated on the first season of each of the shows I analyzed to keep a focused sample size and so I could examine the early writing of the disabled characters and watch their progression or regression as the show developed. The shows had various numbers of episodes in their first season due either to a writers' strike (Handel, 2011) or because of the uncertainty of the networks about whether the show would be successful enough to merit subsequent episodes. Even with the writers' strike, the programs still had a significant amount of episodes to study and produce a thorough analysis.

I looked at dramatic television series airing for 60-minute intervals. This format allowed me to more deeply examine the development of plot devices. I did not look at sitcoms, for example, *Malcom in the Middle*, or cartoons, for example, *Family Guy* or *South Park*, because of the satirical nature of their characters and storylines with respect to disability. Often, these shows use explicit language and poke fun at disabled characters, creating more of a caricature than an "accurate" portrayal of a character.

Through my general research of disability in the media, Internet searches, observations, and multiple viewings of the programs, I found that many studies on the representations of disability in the media were completed in Great Britain (Haller, 2010; Shakespeare & Watson, 2002). Academic analysis from a North American perspective on this particular topic is scarce, especially with respect to TV shows that are considered popular by Nielsen ratings standards. It therefore became significant for me to approach the topic of disability and representation of youth in the media in a detailed and critical study. It cannot just be a coincidence that contemporary television programs are integrating storylines and characters with various forms of disability. Through an analysis of the television programs and a review of the literature both past and present, a richer understanding surrounding the misconceptions, ideologies, negative and positive representations, and perceptions of the social disability construct could be realized.

This study does not attempt to cover the whole spectrum of disability and its representations on television; rather, it looks at some selected current images and how they have evolved to include characters with disability more inclusively. In essence, this means that some television

programs have attempted to integrate characters with differences, in this case disabilities, as part of their storylines. On the shows I examined for my study, characters living with disabilities play supporting roles. I viewed the episodes on DVD and made transcriptions from this same source. I watched and rewatched each episode to pick up the verbal and nonverbal cues expressed by the characters. In particular, I focused on the scenes featuring disabled characters or a discussion of disabled characters.

Units of Analysis

Based on the research questions I posed, I focused on the following units of analysis:

- The television programs
- The characters with disability
- The age range of the characters
- The types of disability addressed

The three shows I sampled for the study—*Glee*, *Parenthood*, and *Breaking Bad*—developed characters and storylines that involved aspects of disability and a specific age bracket that were significant for the chosen areas. Keeping in mind that this study deals with a range of disabilities, as I viewed each television show I was able to get a sense of what types of storylines were important to include as well as the amount that disability was actually included and made central to the show's overall flow.

The Programs

In this section, I look at the television programs chosen for analysis and give more detail explaining why they were significant for this particular study.

Background: *Parenthood*. *Parenthood* on NBC focuses on three generations of the Bravermans, although most of the attention is on Adam Braverman's family. He is considered the "patriarch" of the family as

his father Zeek is fading out due to his age. Adam is the oldest sibling, followed by his sister Sarah, sister Julia, and a younger brother Crosby. The four range in ages from 30–40. All of the characters have children ranging in ages from 5–16. I specifically focused on Adam Braverman's family. He is married and has a teenage daughter, Haddie, and an eight-year-old son, Max. Within the first few minutes of the pilot episode, the audience learns about the struggles the Bravermans are facing because of the "odd" and "eccentric" behaviors Max is displaying. As they grapple with their suspicions, eventually a diagnosis of autism spectrum disorder is made, and the family is thrown onto an emotional rollercoaster ride as they attempt to figure out how to deal with this new information about their son. There is a misconception about the definition of Asperger's syndrome and what it implies, which plays into society's notion of what it means to be on the autistic spectrum. The National Institute of Child Health and Human Development (2014) defines *autism spectrum disorder* as

- Persistent deficits in social communication and social interaction across multiple contexts;
- Restricted, repetitive patterns of behavior, interests, or activities;
- Symptoms must be present in the early developmental period (typically recognized in the first two years of life); and,
- Symptoms cause clinically significant impairment in social, occupational, or other important areas of current functioning (http://www.nimh.nih.gov/health/topics/autism-spectrum-disorders-asd/index.shtml).

In a study about the coping mechanisms of parents of children with autism spectrum disorder, Hastings, Kovshoff, Ward, deqli Espinosa, Brown, and Remington (2005) state: "Parents of children with Asperger's (now referred to as Autism Spectrum Disorder) often report more parenting stress than either parents of children with other disabilities such as Down's Syndrome" (e.g., Rodrigue, Morgan, & Geffken, 1990; Sanders & Morgan, 1997).

Background: *Breaking Bad.* This series first premiered on the cable network AMC in January 2008. It focuses on protagonist Walter

White, a high school chemistry teacher who lives in New Mexico with his pregnant wife and teenage son who has cerebral palsy. Early on in the show, White is diagnosed with stage 3 cancer and given a prognosis of two years to live. With a new sense of fearlessness based on his medical prognosis and a desire to gain financial security for his family, White chooses to enter the perilous world of drugs and crime and ascends to power in this world. The series follows White's exploits as he transforms from an ordinary family man to a risk-taking drug lord who seeks power and control in a dangerous environment.

Throughout the show's first season, White tries to stay true to his family and goes about his everyday life as if nothing major is happening. It takes many episodes before he reveals his cancer diagnosis to his wife and son. The relationship between White and his son, Walter Jr., who has cerebral palsy, is strained at times because of White's private battles. Walter Jr. looks up to his father but often is frustrated with his father's secrecy and reserve.

Background: Glee. *Glee* features a group of high school students (the majority are outsiders) who have a love of singing and performance. The focus stays primarily on the glee club students—The New Directions. These students experience many trials and tribulations competing in the choir competition circuit. As the show weaves in musical performances of everything from old standards, popular/contemporary music, and Broadway tunes, its members deal with disabilities, relationships, race, sexuality, and social issues. *Glee* features two characters (high school students) with different disabilities—Artie who has paralysis and uses a wheelchair and Becky who has Down syndrome. The first season officially ran from September 9, 2009, to June 8, 2010.

Conclusion

This chapter discussed the chosen content for this study and provided an outline and background of the featured shows and the reasons they were chosen. First, I searched for television programs that featured characters with disability. Second, I made sure that a chosen show had at least one character between the ages of 9 and 18. Third, I investigated

the types of disabilities included on each show (physical, emotional, educational). I referred to Nielsen ratings to determine the popularity associated with all three shows that I chose to examine. The purpose of using content analysis in a study of this nature is to better deconstruct aspects of (dis)ability while also looking at race, gender, age, socioeconomic background, and sexual preference among other significant diversity traits. This becomes useful to see where popular culture and attitudes regarding representation of youth with disability currently stand.

> Whereas some scholars approach mass communication messages from perspectives associated with the humanities (e.g., as literature or art), many others employs social science approach based in empirical observation and measurement. Typically that means that these researchers identify questions or problems (either derived from scholarly literature or occurring in applied mass communication), identify concepts that "in theory" may be involved or at work, and propose possible explanations or relationships among concepts. (Riff, Lacy, & Fico, 2014, p. 3)

Using content analysis to study the media is a discreet yet comprehensive way to analyze communications and provide an insight into complex models of human thought and use of language. From the data I examined, I developed a detailed thematic analysis of reoccurring themes, situations, educational contexts, and other significant portrayals of disability, which I examine in the next chapter.

This study is important because, as Kellner (2003a) addresses, popular media are influential in deciding which discourses become dominant and which discourses are marginalized. In an effort to bring attention to the dominant discourses surrounding representations of disability in the media, we may be able to oppose or confront these discourses and bring a greater awareness to and eventually lessen the misinterpretations and disregard with which people with disability are often subject.

Chapter Six

Game of Themes

Focusing on the roles that youth with disabilities (9–18 years of age) play on *Parenthood, Breaking Bad,* and *Glee,* I used a thematic analysis approach to determine the recurring themes, sub-themes, and patterns that may influence audience perceptions of youth living with disabilities. To accomplish an analysis of this nature, I moved away from descriptions to a more categorical, analytic, and theoretical level of coding. The intention of this analysis is to discover where and how youth with disabilities are being represented within contemporary network and cable television and to what effects.

Influenced by postmodern philosophies on deconstructing messages, semiotics, and language (Barthes, 1975; Derrida, 1967/1976; McLuhan, 1964), and using Hall's (2006) theory on encoding and decoding, I examined the limits and parameters of the encoding/decoding process that the audiences of these shows might perform. According to Hall (2006), one of the key characteristics of the process is encoding the "receiver's" acceptance of the message as meaningful discourse, which can then be decoded. The decoded message and its associated meanings "'have an effect,' influence, entertain, instruct or persuade,

with very complex perceptual, cognitive, emotional, ideological or behavioral consequences" (Hall, 2006, p. 165). Within this coding system, individuals might arrive at multiple, oppositional meanings. The coding system serves to condense possible meanings by encouraging an audience to arrive at dominant or preferred meanings, which are secured through multiple viewings, observations, and interpretations (Hall, 2006). However, there are no fixed meanings, since readings can be modified or reinterpreted. This type of decoding is not looked at favorably by television producers and chiefs of marketing (Hall, 2006). Hall goes on to say:

> The consumption or reception of the television message is thus also itself a "moment" of the production process in its larger sense, though the latter is "predominant" because it is the "point of departure for the realization" of the message. Production and reception of the television message are not, therefore, identical, but they are related: they are differentiated moments within the totality formed by the social relations of the communicative process as a whole. (p. 165)

Thus, while multiple meanings can exist, codes can guide the audience as they decode the messages they are receiving. As individuals/ audiences continuously deconstruct meaning, relations of power and language allow for associations and assumptions to take place.

The social model of disability is directly concerned with the deconstructive process. Hall discusses the concept that audience members can participate in decoding messages as they refer to their individual social contexts and experiences, and with that messages may shift mutually.

The thematic tables used to analyze the television programs for this study are for deconstruction and assessing the relationship among language, images, and meaning within the framework of disability. They begin to decode the messages set forth in the media regarding youth with disability. The three television programs are the point of entrance for providing information to better assess the current state of disability in the media and popular culture.

This will be assessed at the conclusion of the study when a summary of the types of storylines, displaying both the positive and negative

traits associated with disability, are organized and interpreted as well as the previous literature discussing notions of disability as represented in the media. An important aspect of organizing this analysis was breaking each theme into a type. Specifically, I identified three distinct theme types—physical, emotional, and academic—which eventually gave way to the color-coded sub-themes of each show. The sub-themes provide a more elaborate description and are grouped together based on the specific dialogue relating to disability and representation.

I chose to describe a theme as *physical* to encompass both the look/ appearance of an individual and a reaction to something (Hahn, 2010). Many connotations can arise from encounters with physical differences—for example, wheelchairs, crutches, facial features, behaviors—of people living with disabilities. In relation to representations of disability on television, the physical aspect is arguably the most critical, since so much is assumed about a disability just by its physical characteristics.

Rooted in psychology, the term *emotional* (derived from emotion) is subjective, bringing together aspects of motivation, reciprocating moods, temperaments, personality, and disposition. The emotional aspect of my thematic analysis was important because of the various emotional responses, feelings, and opinions of the person/people involved with hearing a diagnosis or facing some of the physical obstacles of disability (Schacter, 2011).

I take the term *academic* to mean anything related to education, schooling, administration, and decisions with respect to providing appropriate schooling for students with disabilities. Since schooling is at the core of an adolescent's daily life and the focus and concern of the storylines of the three shows analyzed, this was another important theme to examine.

Last, throughout the analysis, I relate each of the scenes featured in the book to the medical and social models of disability, which I discussed in Chapter 2. The medical model refers to disability as a sickness, so individuals living with disability need to be treated and rehabilitated. The social model attempts to move away from the medical model and is more concerned with the social construction of terms (e.g., the differences between *impairment* and *disability*) and the shared beliefs/meanings of society's view of disability as a whole. By creating

an awareness of the impact of these two models, I hope to provide a clearer view of how youth with disability are represented and how the physical setting, terminology, and dialogue used in the three shows analyzed here are connected to these two models (Clogston, 1990; Haller, 1995; Hughes, 2005; Oliver, 1990).

Table 6.1 is a thematic breakdown for *Parenthood*, *Breaking Bad*, and *Glee*.

Table 6.1. Thematic breakdown for *Parenthood*, *Breaking Bad*, and *Glee*

Parenthood	
Theme Type	**Sub-themes**
Emotional	Stereotyping
Emotional	"The Norm"
Academic	Administration
Academic	Questions of education
Emotional/Physical	Role of mother/wife (femininity)
Emotional	Disconnection/Social gaps
Emotional	Behavioral problems
Emotional	Effect on others
Emotional/Physical	Financial burden
Academic	Questions of intelligence
Physical	Characteristics
Emotional	Internal struggle
Emotional	Empathy from others
Academic	Educational institutions
Physical	No mention of disability
Emotional	Emotional acceptance
Emotional	Emotional denial
Emotional	Emotional bullying
Emotional	Emotional denial
Emotional	Emotional angst
Emotional	Parents: Emotional angst
Emotional	Parents: Emotional optimism
Emotional	Emotional optimism
Emotional	Positive self-efficacy

Emotional	Indifference
Emotional	Resistance
Physical	Intervention
Emotional	Parental conflict
Physical	Disability mentioned
Emotional/Physical	Relating to others
Emotional	Parents: Relating to others
Emotional/Physical	Made for television
Emotional	Seeking help (other family members)
Emotional/Physical	Seeking help
Emotional/Physical	Patriarch/Role of gender (masculinity)
Emotional	Family acceptance
Emotional/Physical	Associated disability/implicit
Breaking Bad	
Theme Type	**Sub-themes**
Emotional	Role of mother/wife (femininity)
Physical	Disability not visible but audible
Physical	Disability partially visible
Physical	Disability not visible
Physical	Visible disability portrayed
Physical	No disability mentioned for remainder of episode
Physical	Requiring assistance from others
Emotional	Sense of belonging
Emotional	Emotional bullying
Emotional	Relating to others
Emotional	Racial discrimination
Emotional	Acceptance from peers
Emotional	Acknowledgment of struggle
Emotional	Inauthentic peers
Emotional	Effect on family from cancer
Emotional	Americana
Emotional	Class struggle
Emotional	Family acceptance
Emotional	Emotional angst

Emotional	Emotional angst (not related to disability)
Emotional	Patriarch/Role of gender (masculinity)
Emotional	Internal struggle
Emotional	Demeaning
Emotional	Stereotyping

Glee	
Theme Type	**Sub-themes**
Physical	Visible disability portrayed
Physical	Associated disability portrayed
Physical	No mention of disability
Physical	Negative view of disability
Physical	Other disabilities mentioned
Emotional	Demeaning
Emotional	Sense of belonging
Physical/Emotional	Effect of music
Emotional	Creating awareness
Emotional	Negative association
Emotional	Discrimination
Emotional	Stereotyping
Emotional/Physical	Fear of being bullied
Emotional	Peers' insensitivity
Physical/Emotional	Misusing disability
Academic	Role of educator
Academic	Administration
Emotional	Submitting to negativity
Academic	Educator: Submitting to negativity
Emotional	Integration
Emotional	Submitting to negativity
Emotional	Empathy from others
Emotional	Confidence builds
Emotional/Physical	Needs rescuing
Emotional	Personal connection
Emotional	Frustration

Following is an analysis of the themes and topics that continuously emerged throughout the study. It was important to include a detailed synopsis of each of the areas relating to disability and representation.

Bullying and Stereotypes

Parenthood. In *Parenthood*, the theme of bullying emerges at certain points during the first season. Eight-year-old Max Braverman is periodically bullied by the boys on his baseball team and in his classroom. In the pilot episode, Max is shown in his school classroom attempting to cut a piece of paper. This task is difficult for him; his fine motor skills are not well developed because of his yet-to-be-diagnosed autism spectrum disorder. Max becomes easily frustrated by his inability to perform the task, and he is pushed to his limit when Amos, one of his classmates, calls him a "freak." The two bullying scenes that are played out early in Season 1 (the classroom and the baseball field) do an adequate job of preparing the audience for what lies ahead for Max and his parents regarding the confusion over Max's behavior, the uncertainty about where he belongs in the school system, and the attitudes and intolerance of his peers and administration in his mainstream elementary school. These various factors are all concerns of the social model of disability, since it deals with the adverse attitudes and obstacles that get in the way of a child who may share Max's diagnosis (Clogston, 1990; Haller, 1995).

Thus, Max's parents, Adam and Kristina, are forced to have a conversation about Max, since he has just been asked to leave his "mainstream" elementary school due to his behavior—he was provoked by another classmate (Amos), so he bit him. At this point in the storyline, the administration is unsure whether Max fits their school profile. These questions about the role of education for students living with a disability and how to deal with the unpredictable nature of Max's behavior cause conflict between his parents, the administration, and school policy. In later sections, I will do a more in-depth analysis of the reaction of Max's parents related to his behavior at school and the consequences for him and his educational future.

Glee. During Season 1, bullying and stereotyping are prevalent in the first few episodes. In the pilot, the audience is introduced to Artie Abram's character, a submissive, quiet, 16-year-old confined to a wheelchair. Intellectually, Artie performs equally alongside his peers, and his love for music and performing helps him integrate with the other students.

Overall, the status of the glee club students is low, and they are not received well by the other students at the school (i.e., football players, cheerleaders, "popular" students). Therefore, bullying is prevalent for all the students involved in the club, which includes marginalized groups such as homosexuals and African Americans. In addition, the glee club students are constantly bombarded by bullies, for example, by having slushy drinks thrown in their faces. The bullying theme is used as a springboard to reinforce the many issues and difficulties facing students with disabilities and their perceptions of how they should be treated in school. The representation of differences and the reactions of the other non-disabled students paints a picture of intolerance and ignorance. Since *Glee* is considered to be a mainstream show, which attracts millions of viewers, its influence on young audiences is significant as it creates an ideology that disability equals weakness and disrespect.

In the next scene, the analysis of the dialogue/scene shows Artie at the center of a bullying tirade by Puck, one of the stars of the football team, and his posse. The scene creates a strong sense of helplessness and entrapment as Artie is violently held inside a porta-potty. The basis for the bullying stems from Puck's anger toward Finn, a former teammate of Puck's, who quit the football team to join the glee club—the rest of the team looks at Finn's behavior as weak and effeminate. Artie is used as the bait because he is in the most vulnerable position physically. When Puck tells Finn that they have the "wheelchair kid inside" the porta-potty and that he plans to flip it over with Artie still inside, Finn recognizes the danger and tries to convince Puck not to do it, but Puck ignorantly makes the statement: "He's already in a wheelchair." The exchange between Puck and Finn over Artie's well-being puts them in positions of power and authority over Artie because he is in a wheelchair and unable to break free of confinement. Ignoring Puck's threats, Finn finally opens the door to an extremely grateful Artie. Artie

is overwhelmed with fear and disgust at the smell of the toilet where he was trapped. Puck refers to Artie and the other glee club members as losers and the club as a "homoexplosion." The scene is laced with derogatory slurs and intolerance, a bullying tactic often used in relation to disability (Haller & Ralph, 2006). Once again, this behavior is influenced or supported by the medical model of disability, which leads to harsh and explicit language targeting individuals living with impairments. Artie feels a sense of empowerment with Finn by his side, and as the scene ends, he hisses at Puck and the other members of the football team, finally able to retaliate now that he has the support of an able-bodied person by his side after being "rescued."

Breaking Bad. The bullying theme runs rampant on all of the three shows that I analyzed. In *Breaking Bad*, the first episode of the series captured this particular theme in a powerful way. The major difference between the bullying scene in *Breaking Bad* and those in *Glee* and *Parenthood* is that the parents are present when the verbal abuse occurs, and they intervene to protect their son. As a result, Walter Jr. is left powerless and his personal agency is undermined when his father steps forward in an attempt to glamorize his role as the patriarch of the family and to regain control of it and his manhood.

This scene is one of the last of the pilot episode. Walter Jr. is in a dressing room with his parents trying on jeans, and clearly he is having some difficulty pulling them on and off. His mother asks if he needs help from his father, to which he hesitantly replies, "Yes." White enters his son's dressing room and begins to help him pull up his pants. An intimate father-son moment occurs, and the audience is offered some insight into the difficulties Walter Jr. has faced over the years due to his cerebral palsy. White acknowledges his son's struggles and lets himself be vulnerable to the situation. When Walter Jr. finally is able to pull his jeans on, he steps outside of the dressing room to show his mother and to look in the mirror to see if he likes them. This is the moment when the themes of bullying, emotional angst, and stereotyping enter the storyline. A group of teenage boys make loud comments in a derogatory tone meant to mimic the speech impediments of both White and Walter Jr. Walter Jr. and his parents try to ignore the boys, but they become more and more inappropriate as the scene continues.

Walter Jr.'s mom, Skyler, wants to go over to speak to the boys and ask them to stop, but in a quiet fit of rage, White tells her to stay put, and he walks out of the store, leaving both Skyler and Walter Jr. in a confused state. As the scene focuses in on the boys continuing to degrade Walter Jr., White enters the store, walks directly over to the main bully, and begins kicking him in the leg. He is furious: "What's wrong, chief, having a little trouble walking?" Clearly, this is done for the purposes of being made to—pardon the expression—"walk in someone else's shoes." The boy who White attacks is shocked and angry, and his two cohorts watch in a frozen panic. The mood of the scene shifts to White becoming a hero of sorts and truly acting like the patriarch of his family, displaying "authentic" masculinity in his defense of his son.

In this bullying scene, the depiction of Walter Jr. is focused on his physical limitations, which the medical model of disability stereotypically supports. Often, "non-disabled" individuals use negative language and labels to stereotype people living with disabilities (e.g., Walter Jr. is a baby in need of his mother's help to try on his pants because of his cerebral palsy), labels that are derived from the medical model still so widely associated with disability. Thus, Walter Jr. is approached outside of a school setting in a public forum with his parents present, where he could be rescued from the deliberate name calling and belittling. The bullies are a group of boys around Walter Jr.'s age, and they do not acknowledge Skyler even though she is standing right next to her son. In her matriarch/peacemaker role, she tries to quietly defuse the situation by advising her son to ignore them, but once White gets wind of the situation, he steps in and acts out in violence and aggression because of his frustration with his recent diagnosis of terminal cancer and his son's daily limitations due to his cerebral palsy. Throughout the first season, Walter Jr. plays an important role in the show, but the only scene that openly reflects bullying is the one described above. In *Breaking Bad*, Walter Jr.'s character is bullied because of his physical disability (Swain, Finkelstein, French, & Oliver, 1993).

Comparison of Bullying Scenes

In all three shows researched for this study, at least one scene involved the bullying of a disabled character. In *Breaking Bad* and *Glee*, the characters are rescued by an able-bodied individual, and the bullying starts off with slurs. The disabled character is already in a weakened position because he is either caught off guard or physically unable to defend himself.

The bullying scenarios in *Breaking Bad* and *Glee* differ from that of *Parenthood* because of the acute awareness the characters have of how they are treated when they are being targeted. Max's autism spectrum diagnosis causes him to be more removed and unaware of his surroundings socially. Therefore, he is not directly implicated in the hostile words directed toward him by his peers.

Seeking Help, Intelligence, Diagnosis

The differences between Max and his peers are reflected in one of the opening scenes of the pilot episode. In that scene, Max is on the little league field while his father and grandfather are shouting from the sidelines. It is apparent throughout the scene that Max is uncomfortable and disconnected from the team and the game; he is out there for the sake of his parents. While being pushed to participate, the echoing of the other children and the adults is overpowering to Max and causes him to be distraught.

Another sub-theme in *Parenthood* is the patriarch/masculinity role taken on by Adam, the father. After hearing about his son's potential diagnosis of autism spectrum disorder, he becomes protective and lost in denial. The burden of work, finances, supporting other family members, and intimacy with his wife all add to the stress of his situation, which fits with the theme of emotional angst. In addition, the news of Max's diagnosis creates conflict between his parents.

The emphasis of this scene is on the man/father acting out his emotions in a hostile/uncomfortable manner verses the woman/mother

being an understanding caregiver willing to work out the issue in a way that will best suit her son. This also brings up the role of gender and acceptance by the parents and makes the audience connect from the internal conflict facing Max's parents rather then what Max is dealing with.

In *Parenthood*'s Episode 2, Season 1, "Man Versus Possum," the Braverman family seeks an intervention and explanation for the characteristic behaviors of autism spectrum disorder that are causing the difficulties that Max is experiencing with respect to connecting to others. Questions arise regarding Max's intelligence, and a specialist, Dr. Pelikan, does an assessment to provide a proper diagnosis. In the scene, Max seems to have connected well with the doctor, and the parents are optimistic about the results. At the end of the session, the doctor concludes that Max is highly intelligent but has characteristics associated with autism spectrum disorder syndrome. After receiving this diagnosis, Adam and Kristina are obliged to find a suitable school for their son, one that will properly accommodate his learning differences. They are shocked by this information, but Adam quickly takes on the role of patriarch, since he wants to find the solution to the problem and help Max "get better," although this type of behavior may be a way to try to make the diagnosis go away by denying it exists. Again, the audience senses the difficulty and helplessness expressed by Max's parents (especially Max's father) after they hear the diagnosis and after they realize that Max no longer fits in a "traditional" learning environment. Thus, the social model of disability is an important tool for creating an awareness about the difficulties of individuals who are thought to be outside the "norms" of society and are labeled as such.

The Role of Education/Educators

In one of the bullying scenes in *Parenthood*, an action is played out by Max in the classroom, and a decision regarding his future at his current school is made. As a child diagnosed with autism spectrum disorder, where does Max fit into the overall structure of the school?

> Lukes's (1974) work on power and dominance posits that the bias of the system is not sustained simply by a series of individually chosen acts, but also, more importantly, by the socially structured and culturally patterned behaviour of groups, and practices of institutions, which may indeed be manifested by individual inaction. (pp. 21–22)

Although Lukes's argument regarding power, policy, and decision making is complex and multidimensional, his overall message is critical in relation to the dominant structures already put in place by those in power positions. This argument supports my analysis of the portrayals of youth with disabilities and the power struggles they face regarding education, access, acceptance, and society's overall understanding of disability. Often, many of the misconceptions regarding disability are perpetuated by those in powerful positions who make decisions on behalf of a disabled individual, which leave him or her powerless and marginalized.

The scene in *Parenthood* addressing Max's imminent schooling and educational ability is indicative of limitations put on those individuals dealing with disability in a mainstream school. It is important to note that in *Parenthood*, Scene 5, "The Role of Education/Educators," technically airs during the season before Scenes 3 and 4 listed in the analysis. It is discussed later because of the thematic flow of the analysis, since I am dividing up the topics to reflect the most relevant and frequent storylines appearing on the selected shows. Often, the disabled are misunderstood and misplaced, so the only viable option seems to be to banish them to a more expensive or overcrowded institution. The batteries of tests and assessments required for the decision about the future of the disabled individual box them in and create a stigma.

The parents are unclear of their son's status and are forced to seek outside help to assess Max and help determine where he fits in the narrow structure of the education system. This could be directly related to how the social model relates to disability; the role that a school administration plays in the future of a disabled child is indicative of how they are perceived. This ambiguity is a common barrier felt by many educators and parents. So, the question arises: Is inclusion an effective mode for educating students with learning differences, and at what cost?

At this point in the storyline, Max's parents seem to be given only one option—to send Max to a costly specialized school called Footpath Elementary. As white, middle-class, educated individuals, they are fortunate enough to be able to consider this option for their son. However, the school has an extremely long waiting list, and with the uncertainty about whether he will get in with such short notice, the parents feel a great deal of anxiety about their son's future. This fictional situation is reflective of the real role that powerful institutions fail to play with respect to special needs education. A "proper" diagnosis is needed for services, which the parents must often seek out on their own and assume financial responsibility for; after the diagnosis, it is the parent's responsibility to find a facility that best suits the needs of his or her child. Finally, a school has to be willing to accept the child into its structure (Smith & Tyler, 2009).

The overarching ideology of the school system can be related to the scene in *Parenthood* that focuses on the choice Max's parents must make regarding his schooling, which can be understood through Gramsci's (1971) theories regarding schooling and education. Briefly, Gramsci's views on education are still at the center of the educational debate today with respect to the relationships among education and class, vocationalism, and the ideology of the "comprehensive" school. Gramsci described schools as socially driven institutions with their own characteristics and guidelines based on the social group that administers them. Schools are "intended to perpetuate a specific traditional function, ruling or subordinate" (p. 40). Gramsci's theories on education have also influenced the research on conventional schooling and education through the work of Giroux (2001), Sandlin, O'Malley, and Burdick (2011), Kincheloe (2008), and McLaren (2006).

In another scene, Max's parents are speaking to the principal in charge of Footpath Elementary. They are desperate to get their son into this school and are pleading with the administrator to allow him in.

In a made-for-television moment, the phone call and answer they have been waiting for comes, and the family optimistically celebrates the acceptance of Max into an institution equipped to deal with his autism spectrum disorder. This moment of triumph emphasizes the intolerance of the public system regarding students living with disabilities

and alludes to the difficulties that families often face when trying to find the right school for their child/children.

While *Parenthood* deals primarily with Max's intellectual disability—his autism spectrum disorder—and his family's attempt to find the proper schooling for him, *Glee* and *Breaking Bad* are driven by the physical disabilities (paralysis and cerebral palsy) of their characters. Although *Glee* includes Becky, a character with Down syndrome, she is only in three episodes of the first season. Nothing is explained regarding her differences or what types of challenges she faces when attending a mainstream public school. She appears and, while assumptions are made by her teachers regarding her overall appearance and stature, they are dealt with in a safe manner by ignoring her differences. There are more significant links to Coach Sylvester and Becky in later seasons.

In Season 1 of *Glee*, Episode 9, "Wheels," focuses on disability and the lack of adaptive equipment for individuals with physical difficulties. In this episode, the glee club is trying to raise money for a bus that can accommodate Artie's wheelchair, so he can join the rest of the club at their upcoming performance at the sectionals. This episode in particular is a stellar example of the types of situations with which the social model of disability is concerned. Often, people living with disabilities face hardships generated by the lack of support and access within certain public spaces (in this case, a special vehicle that could transport Artie to his performance with his peers), which lead to isolation and feelings of being a burden to others (Clogston, 1990; Haller, 1995).

In the beginning of the episode, Will (the glee club director) and Principal Figgins argue about the unfair nature of the school for not providing Artie with transportation to the event due to budget cuts. Many of Principal Figgins's statements are ignorant and insensitive.

The inner turmoil and frustration that Artie must suffer from being in a wheelchair is a key theme throughout the episode. Artie expresses himself best through music and movement, and there is a powerful scene where he is onstage by himself, which represents how he internalizes his disability. Artie moves about on the stage while in his wheelchair, dancing to the music. The scene draws on the empathy of the audience and is part of the dramatic arc that moves toward an understanding of differences between individuals using wheelchairs due

to paralysis or other situations and individuals who do not require or have not experienced using wheelchairs.

During the episode, some of the glee club students use borrowed wheelchairs for a few days to gain a better of understanding of what it is like to be confined to a wheelchair. They experience the difficulties of reaching for things and have food thrown in their faces, but overall, they seem to adapt fairly well to their temporary situations, and they act as though nothing much has changed.

The glee club puts together a "Handicapable Bus Bake Sale" to raise money for the adaptive bus for Artie. This is the scene in which Becky Jackson's character is finally introduced. She joins the bake sale scene with Brittany one of the glee club students who is perceived as having a low IQ, and plays the role of the *dumb blonde,* not aware of the world around her. The other students are surprised by Brittany's comfort while walking through the crowded cafeteria with Becky, a young girl with Down syndrome who is clearly different from the others. The students are confused, particularly Santana, one of the tough, popular, promiscuous girls at the school. Brittany comes across as unaware and unaffected by Becky's syndrome, which helps establish an atmosphere of inclusion and a sense of belonging for Becky.

While the majority of the "Wheels" episode deals with acceptance and understanding, some of its scenes contribute to negativity and stereotyping. Since the nature of *Glee* is at times farcical and blunt, many of its marginalized groups are not treated fairly. Everyone is a target at some point.

In *Glee*, the educators and administration discuss the positive actions taken by the glee club students to raise money and awareness for their peers with disabilities. However, Sue Sylvester, the strong-willed cheerleading coach, is not impressed and makes some insensitive comments about the time wasted on this cause. In the formulaic tradition of television, "good" and "bad" characters are developed, so the audience is able to root for the "good guy." The remarks that Sylvester makes are so extreme that her words become nonsensical when contrasted with the attempts the episode makes at being inclusive through the constructive actions taken by the glee club students. Nevertheless, overall, the episode divides the educators and

the students (excluding Will Schuster, the glee club director, who is trying to encourage the students and advocate for them). Whereas the students make the effort to raise money for Artie's bus, the administration tries to undermine their efforts. The dynamic played out portrays the students as the compassionate group and the educators as insensitive and uncaring, with no regard to the progress made regarding disability over the last 20 years (e.g., Americans with Disabilities Act of 1990).

Sue Sylvester—the sarcastic, demeaning cheerleading coach—runs auditions alongside Will Schuster, who is known for being fair and balanced with his students. The purpose of the audition is to find students who want to join the cheerleading squad. Throughout the scene, Sue is incredibly blunt and critical of all the students who are auditioning, until Becky Jackson enters the scene with a jump rope. Will begs Sue to "be nice" and to give Becky a fair chance as she puts herself out there.

In general, this scene featuring Becky is laced with many different meanings. The audience knows Becky has Down syndrome by the way she appears physically and her struggles with the jumps and overall routine. However, the fears that Will (and the viewing audience) may have that Sue will dismiss Becky and treat her more harshly because of her disability are relinquished when she picks her to be on the team with other able-bodied students. Although this unexpected shift in attitude from Sue Sylvester may leave the audience questioning her intentions, it also turns the scene into a positive and optimistic movement toward inclusion and equality.

Building Toward Inclusion

In an interesting turn of events, before Becky makes the cheerleading squad, she is shown practicing with Sue. She has a jump rope in her hand and is struggling with the movements. Sue is berating Becky, the way she would any student at the school. As Will looks on, he is disgruntled and upset about how Sue is speaking to Becky's disability. Sue explains to Will that her treatment of Becky is no different than how she would treat any other student and that Will's statement about her

being "different" is exactly the problem with how society treats individuals with disabilities.

Later in the episode, we learn that Sue has a personal connection to Down syndrome. Her older sister, who is in an assisted living home, has Down syndrome, and Sue looks up to her and admires her greatly. In general, the "Wheels" episode was pivotal to the first season because of how it took on the following controversial themes: inclusion, empathy for others, portrayals of disability, role of educators with respect to disability, stereotyping, and discrimination.

Acceptance, Tolerance, Inclusion

Although the "Wheels" episode centers on Artie's disability, his character is finally given a platform for growth. Artie begins to have a romantic relationship, and his peers gain a sense of awareness about what it's like for him to be confined to a wheelchair. Nevertheless, disabled viewers in the audience may question the "truthfulness" of the episode, and *Glee* in general, because Artie's character—paralyzed from the waist down and restricted to a wheelchair—is played by an able-bodied actor, which perpetuates the stereotype of disabled actors not being hired to play major television roles because of their limitations.

On the other hand, this episode also introduces Becky Jackson's character (a real person with Down syndrome playing the role), which brings authenticity to the show. Although there is not much explanation about how her character fits into the overall trajectory of the school, the producers are trying to take a well-rounded approach toward inclusion and acceptance.

Building Relationships

As the episode continues, Artie's character grows. He is given the task of choreographing a dance number with wheelchairs, and he begins a romantic connection with Tina, another glee club member who has her own insecurities and perceived difficulties (stuttering). It is unclear whether Tina and Artie are connecting because they are dealing

with their different adversities or if they are genuinely attracted to one another. Artie wants to make it apparent that his physical disability does not impede his ability to be sexually active. Although he is paralyzed from the waist down, he still has use of his penis. The episode attempts to explore his "normal" wants and desires toward girls his age.

In *Glee*, the dialogue between Artie and Tina about their feelings toward one another and Artie's ability to teach a dance routine to the other students are attempts to teach empathy for and understanding about how difficult it is to manipulate a wheelchair and to be part of the mainstream school culture.

The theme of building relationships attempts to portray disability in a positive light, with an emphasis on the inclusive attitudes of the students. The romantic relationship between Artie and Tina is used to show how characters with differences due to disability can take on a central role in the life of a mainstream school and display the everyday difficulties and situations that the "typical" high school teenager faces. Scene 6 has many characteristics that are the concern of both the medical model and social model (Clogston, 1990; Haller, 1995) of disability. Artie's concern with his paralysis from the waist down and his apprehension about his ability to perform sexually with a partner is within the purview of the medical model. The social model of disability can be used to better understand the barriers that make it difficult for Artie to participate in certain situations at the school, which make him feel isolated and distant. The acknowledgment of the bond between Artie and Tina helps the storyline become relatable and meaningful to an audience.

Misusing Disability for the Purposes of Gaining

In Scene 6, the audience is made aware that Tina has a stutter and that the other students are beginning to notice the extra attention and privileges gained by exploiting their temporary confinement to a wheelchair. Although it seems that Tina and Artie are connecting as a result of their differences (paralysis and stuttering), later the audience learns

that Tina was faking her stutter in an attempt to get attention and empathy from others.

In another scene from the episode "Wheels," Finn, one of the jocks, uses his wheelchair to obtain a job that previously was unavailable to him. When another glee club member learns of this, she takes the initiative to go into the restaurant with Finn in his wheelchair and angrily express her disappointment that the restaurant is not being fair to "handicapable" Finn. The social model of disability can be used to understand this scene's significance (Clogston, 1990; Haller, 1995).

In *Glee*, disability is represented negatively when Puck, another jock, explains to the other students in the glee club how he managed to get access to medicinal marijuana from Sandy Ryerson, a teacher. Puck tells Ryerson that he injured his spinal cord as a result of a shark attack at an aquarium. Feeling great empathy for him and his "disability," Ryerson passes on the marijuana to him without blinking an eye. This is an obvious slapstick made-for-TV moment.

After viewing this scene, it is clear that Puck's character is turning a physical disability into a punchline. The scene is meant to be comedic and show the dark, thoughtless side of Puck's character. The seriousness and emotional distress associated with a spinal cord injury is not meant to be the focus; rather, it is turned into something playful. Puck's character wants to obtain marijuana, and so he fakes a major injury, and Ryerson fails to respond as a responsible educator. Ryerson plays into the stereotypical attitude discussed by the social model of disability (Clogston, 1990; Haller, 1995) of feeling sorry for Puck because of his disability (which the audience knows is fake).

In a final scene in "Wheels" relating to the misuse of disability to gain something, Tina goes out on a date with Artie. Initially, they connect because Tina has a "stutter" and Artie feels comfortable around her. However, after their first date, Tina admits to Artie that she has been faking her stutter since the sixth grade because she wanted to get out of a speech assignment. Artie is extremely disappointed and automatically retreats from Tina's explanation. After hearing Tina's apology, Artie makes a critical statement: "I am too... I am sorry that you get to be normal and I am stuck in this chair for the rest of my life. And that's not something I can fake." Once again, Artie's statement acknowledges the

difficulties of being bound to a wheelchair and feeling a constant sense of disconnection from others. The behavior of some of the able-bodied characters who used their wheelchairs to learn a life lesson but took advantage of their situation demonstrates a lack of compassion and selfishness to gain. Nevertheless, the Baudrillardian notion of *hyperreality* also haunts these multilayered interpretations, since Artie, in real life, is not in a wheelchair.

Breaking Bad also features scenarios in which disability is misused or used for the purposes of gaining empathy from others. Similar to *Glee*, a character with a disability uses it to gain things because he is visibly different (wheelchair, crutches, etc.). In Season 1, Episode 5, "Gray Matter," Walter Jr.'s frustration toward his father grows more profound. The audience learns that White is refusing treatment for his cancer and has grown distant from his family. As Walter Jr. tries to cope with his family's situation and make some sense of his life, he resorts to behaviors typical of a teenager who is acting out.

In *Breaking Bad*, Walter Jr. is outside of a convenience store with two other boys. He is visibly disabled, using his crutches for support, while the other boys have no visible disability. They all seem to be friends. The three are trying to score alcohol from a store patron who is willing to take their money and buy them the drinks. When the group finally finds the person they think will get them the alcohol, they ask Walter Jr. to approach him. When Walter Jr. asks why he should be the one, another boy replies, "Give me the crutches, I'll do it." Clearly, Walter Jr. is the person who would gain the most compassion from an older person in a position to buy them illegal liquor. Since Walter Jr. wants to look cool, he makes the move toward asking the customer, and he subsequently gets caught for possessing alcohol while underage.

In this scene, Walter Jr.'s disability is glorified for the purposes of gaining alcohol. Although teenagers have a tendency to display adverse types of behavior toward one another in times of distress, the viewer is left questioning the motives of the friendship among the boys. When faced with disciplinary measures after the police catch Walter Jr., the boys seem to abandon their friendship with him. Many aspects of this scene perpetuate the stereotypes regarding the relationships between the characters with a disability and those without. Is Walter Jr.'s

friendship with the other boys based on their pitying him and wanting to use his visible physical differences to obtain illegal substances, or do they have common interests and respect for one another?

Additional Critical Scenes Featuring Disability

Although it is apparent from Episode 1 that Walter Jr. is physically disabled (he walks with crutches and has some speech impediments), it never becomes the main topic of conversation. Even when Skyler, his mom, is pregnant, the storyline doesn't mention the possibility of the new baby having cerebral palsy, which to this viewer seems somewhat unrealistic.

Many pivotal familial moments occur between Walter Sr. and Walter Jr. before the father becomes a chemist turned methamphetamine producer. White deals with his bleak cancer diagnosis and grows more and more hopeless and depressed. During a scene in Season 1, Episode 5 ("Gray Matter"), a family intervention is staged to figure out why White is refusing chemotherapy to fight his cancer. The characters featured are Skyler, Walter Jr., and Hank and Marie (Walt's very involved brother- and sister-in-law). Walter Jr. steps in as the voice of reason, comparing his daily struggles with cerebral palsy as something he and his family have overcome together. He specifically mentions his family's strength in sticking by him and never giving up (explicitly referring to his crutches). The scene among family members plays out as Walter Jr. expresses his frustration with his father for chickening out of taking the chemotherapy; he reminds his father that he has no choice and needs to work with the situation with which he has been dealt—cancer.

This scene attempts to balance the hardships faced by White due to his cancer diagnosis with what Walter Jr. has faced since birth, thus personifying the positive aspects of a family joining together to create a better environment for their son and instill a positive outlook when faced with a challenging situation. These moments in *Breaking Bad* illustrate that Walter Jr.'s character has an awareness of and a strength to overcome his disability. He is not defeated by the physical difficulties often associated with cerebral palsy.

Conclusion

This thematic analysis has been used to investigate the three programs chosen for the present study with respect to their representations of youth with disabilities. It is a tool used to code for qualitative research. "In providing access to discoveries and insights generated through qualitative methods, thematic analysis expands the possible audience for the communication and dissemination of ideas and results" (Boyatz, 1998, p. vii). Through color-coding and organization of topics, many recurrent themes emerged dealing with disability, stereotypes, relationships (parental and peer), and education. From the analysis, I found that some of the themes overlapped and some stood on their own, and I have expanded on what was discussed in Chapter 5, contextualizing the content analysis and enriching the body of research. The next chapter summarizes and discusses the content studied in more explicit detail. The themes that will be addressed more closely are the following:

- Bullying/stereotyping
- How education and educators are implemented in identity construction of individuals with disability
- Seeking help, intelligence, and diagnosis
- Building relationships and inclusion
- Misuse of disability for the purposes of gaining, the disabled actor vs. the non-disabled actor playing the role

The analysis will be grounded with methodological support from theorists such as Hall (1996) and Baudrillard (1995) to enrich the text and basis for research of this topic.

"Breaking" Down the Content

The purpose of this study was to examine the various themes related to disability, particularly youth with disability, in three TV series—*Glee, Parenthood,* and *Breaking Bad*—to get a better sense of how these popular television programs include this population in their repertoire. This work builds upon previous research in the field of disability, media, and critical youth studies.

I chose to examine the representations of youth living with disabilities in three primetime television programs on two major networks (NBC, Fox) and one cable network (AMC). Specifically, I looked at episodes featured in Season 1, each an hour long. Through a thematic analysis, I found major themes related to the depictions of contemporary disability in these dramas. I decided whether a pattern was a theme based on its frequency and relevance to disability as it exists in the educational environment of the high schools of these programs. For example, was disability depicted inclusively? Are the images used to represent disability stereotypical? Is bullying involved in these representations, and if so, is it physical or emotional? Are the educators and schools integrated into the lives of the disabled characters, and

how are they portrayed? These are the types of questions that started to form as I examined the shows. I also found that these were the topics most widely discussed in the media on news programs and on social networking sites (i.e., Twitter, Facebook).

The first of the major themes focused on the bullying and stereo-typing present in all three shows, which were depictions of situations involving disabled adolescents. Briefly, the American Psychological Association (APA) (2014) defines *bullying* as "aggressive behaviour that is intended to cause distress or harm, involves an imbalance of power or strength between the aggressor and the victim, and occurs repeatedly over time. Bullying may take many forms, including physi-cal, verbal, relational and cyber." The APA also pinpoints specific types of groups that are more bullied then others, and individuals living with disability (physical or emotional) are among the most targeted. Keeping this in mind, below I list the sub-themes that emerged from the three shows I examined. Using Hall's (2006) encoding/decoding theory, I found that an overarching emotional tone of dominance and masculinity was developed through the codes used to portray the char-acters doing the bullying: "Moreover, they emerge within the play of specific modalities of power, and thus are more the marking of dif-ference and exclusion, than they are the sign of an identical naturally constituted unity" (Hall, 1996, p. 4). The theme types—academic, emo-tional, and physical—have been decoded to reveal the power struggles and representations of the other. I include the more explicit sub-themes by show and group them together according to their relationship to the central themes, since they are the fundamental basis for decoding the relationships between disability and bullying.

The bullying sub-themes in the three shows are as follows: *Parenthood*—internal struggle, emotional bullying, behavioral prob-lems, role of teacher, emotional denial, role of mother/wife (feminin-ity), patriarch/role of gender (masculinity), educational institutions; *Breaking Bad*—visible disability portrayed, relating to others, requiring assistance from others, emotional angst, internal struggle, stereotyp-ing, emotional acceptance, empathy from others; and *Glee*—discrimi-nation, peers' insensitivity, helplessness, needs rescuing, demeaning, confidence building.

The one common thread in each of the bullying sub-themes is the internal struggle of the character being bullied. Their sense of helplessness and emotional angst is visible through their facial expressions and body language. Artie (*Glee*) and Walter Jr. (*Breaking Bad*), who have visible disabilities for which they are being ridiculed, share a common experience. Both characters are assisted by an able-bodied third pArtie who helps them get out of their toxic situation. A peer from the glee club helps Artie, and Walter Jr. is helped by his father. In *Parenthood*, Max has no visible signs of disability but displays behavior that causes his peers to react negatively toward him. All three shows clearly articulate the effect bullying has on the ability of these characters living with disability to develop peer relationships and to feel secure and confident.

Another common theme in these shows is the role played by education and educators in the problems faced by disabled individuals. The sub-themes are as follows: *Parenthood*—educational institutions, patriarch/role of gender (masculinity), role of mother/wife (femininity), emotional denial, questions of education, seeking help; *Glee*—role of educator, administration, negative view of disability, stereotyping, discrimination, integration, visible disability portrayed, helplessness, insensitivity, submitting to negativity. As the bullying themes from *Parenthood*, *Breaking Bad,* and *Glee* mentioned above are decoded and analyzed more closely, patterns of the "other" begin to appear more clearly, which can be understood in the context of Hall's (1996, 2006) theory regarding the representation and the construction of identities:

> Precisely, because identities are constructed within, not outside, discourse, we need to understand them as produced in specific historical and institutional sites within specific discursive formations and practices, by specific enunciative strategies. Moreover, they emerge within the play of specific modalities of power, and thus are the sign of identical, naturally constructed unity—an "identity," in its traditional meaning (that is, an all inclusive sameness, seamless without internal differentiation). (p. 17)

In essence, the identity of the other is constructed on an association with anything outside of the norm: "Identities are constructed through, not outside of difference" (Hall, 2000, p. 17). Thus, as I mapped out the

constructions of identity, I began to see the importance of the reactions of parents, educators, peers, and other family members toward these young people living with disability in the educational environments of the three programs.

In *Parenthood* and *Glee*, Max and Artie are not only being mistreated by their peers, but at times, the school administration is responsible for the injustices in the school. In *Parenthood*, the principal alerts Max's parents that she does not feel that their school is the right fit for Max based on the behaviors he has displayed and that he needs to be assessed. In *Glee*, the school does not have the proper accommodations for Artie and his wheelchair, so a concerned teacher approaches the principal to request that something be done to rectify this problem. According to the principal, due to lack of funds, proper ramps cannot be provided for Artie to comfortably access certain areas of the school and, more importantly, to ride on the bus with the other students in the glee club.

This theme also represents the way that the educators in *Glee* (Will, Sue, and Sylvester) and *Parenthood* (principal, teacher) can influence the future of a student living with disability. In *Glee*, Artie has a personal connection with Will that cultivates advocacy for Artie and his condition. Sue Sylvester's relationship with Becky Jackson also stems from a personal connection (the connection she has with her older sister who has Down syndrome), which leads to inclusion and tolerance.

In *Parenthood*, on the other hand, Max's behavioral difficulties and learning differences create an environment for which the educators are not equipped to respond appropriately. Therefore, they play a significant part in evicting Max from his current school but little in the way of support to help him find a school better suited to deal with his autistic spectrum disorder.

Another theme falling under the umbrella of education—seeking help, intelligence, diagnosis—once again deals with the issue of displacement and feelings of uncertainty in regard to where a disabled student could be best educated. This theme emerges primarily in *Parenthood*, but it was important to include because it raises many concerns related to the education of those students living with disability. The sub-themes were seeking help, behavioral problems, relating

to others, role of mother/wife (femininity), patriarch/role of gender, disability mentioned, questions of intelligence, questions of education, emotional acceptance, parents: emotional angst, parental conflict.

Human differences and displacement are areas discussed by Hall (1997) as signifiers related to social constructions of language. As individuals are classified and grouped together into various molds, they are acting on society's need to create order and a sense of positionality and dominance (Hall, 1997; Hiles, 2006). Placement of individuals living with disability into alternative schools and classrooms creates the divide between ability and disability, once again emphasizing the importance that the social model of disability brings to the overall analysis of characterizing youth with disability on television. It is important to note that the social construction of differences is not something permanently set in place as conditions change over time, circumstance, and understanding. Thus, Max's diagnosis of autism spectrum disorder leaves him vulnerable to its many negative connotations. His parents are unsure where to turn for help and are forced to go outside the mainstream school system to figure out the best course of action for their son's future (Shakespeare & Watson, 1997; Shapiro, 1993).

The third theme running through all three shows is inclusion and the building of relationships between the disabled characters and their able-bodied peers. All three shows explored this theme in different forms. In addition, the sub-themes overlap with the themes that focus on the role of education and educational institutions. In *Glee*, Becky Jackson is played by an actress who has Down syndrome. The topic of inclusion is best exhibited during the scene where Becky is trying out for the cheerleading squad. She does not receive special treatment from the coach, which at first upsets one of the teachers sitting in on the auditions. The teacher's initial reaction is that the coach is insensitive and unfeeling, but the audience later learns that the coach has a sister also living with Down syndrome, who she adores and looks up to. *Glee* never addresses Becky's Down syndrome as a negative thing nor does it go into any depth as to how living with Down syndrome in a mainstream school may affect her ability to fit in or learn.

In *Parenthood*, Max is included in the mainstream high school until he is assessed for his behavioral difficulties. This inclusion is short

lived, since Max is subsequently transferred to an alternative school for students with autism spectrum disorder. Before Max transfers to the alternative school, he is ridiculed and bullied by the other students in his school. His teachers are unable to deal with his behavior, and his learning differences are not addressed appropriately.

In *Breaking Bad*, Walter Jr. attends a mainstream school and has no known learning problems. Due to his cerebral palsy, he must walk with crutches, and he has some facial disfigurement when he speaks. The show provides little discussion about his disability, except for one scene in which his family is meeting to talk about his father's cancer diagnosis. Other than that, Walter Jr.'s character has an inclusive role in the show where his disability is not the main focus.

In the fourth theme, misuse of disability for the purposes of gaining, the theoretical model of social disability as well as Hall's (2006) encoding/decoding theory are noted. In *Glee* and *Breaking Bad*, the theme can be broken down into the following sub-themes: *Glee*—role of educator, misusing disability, educating (teachable moments); *Breaking Bad*—visible disability portrayed, sense of belonging, acceptance from peers, stereotyping, demeaning, inauthentic peers, power struggle. The students/peers of the characters with disability are seemingly unaware of what it is like to live with a disability, whether it be physical or emotional. The treatment of disability as a disease or an impairment still runs rampant in the way it is socially constructed or addressed. Disability rights activists are working hard to break the cycle of misrepresentation and mistreatment of individuals living with disability (Charlton, 2000; Stone, 1997). In both episodes deconstructed, disability is glorified and misused for the benefit of able-bodied individuals. Wasserman, Asch, Blustein, and Putnam (2013) argue that

> Most nondisabled people, after all, are not told that they are inspirations simply for giving the correct change at the drugstore. Perhaps there would not even be a "disability experience" in a world without the daily indignities, barriers, and prejudices that characterize life with disability almost anywhere.

The distinction between disabled and able-bodied individuals is more noticeable in the episodes discussed in the following paragraphs, since

a certain dimension of power and authority colors the actions of the characters who misuse disability for their own benefit.

In *Glee*, the students in the glee club decide to come together in the episode "Wheels" to help raise money for a wheelchair-friendly bus that would allow Artie to ride to the sectionals with his fellow classmates instead of traveling separately. Will, the glee club teacher, attempts to make this a teachable moment, instructing his students to try getting around in a wheelchair for a week to get a sense of what Artie goes through on a daily basis. This episode addresses the issue of inaccessibility in public space. Finn takes advantage of being temporarily in a wheelchair when he demands a job that was not available to him as an able-bodied person; he uses the wheelchair as a ploy to get the manager to agree to hire him, exploiting his temporary handicap to gain a job and empathy from others.

In the same episode, a similar situation occurs when Puck fakes a spinal cord injury and uses his wheelchair to get medical marijuana from a teacher. Once again, this behavior takes advantage of people's positive compassion so as to benefit from a temporary disability.

The theme focused on building relationships ties in with the misuse of disability theme. Once again, *Glee* presents an able-bodied student who fakes a disability to get attention. Tina fakes a stutter to push others away so they won't judge her for being a "weird" person. Yet her fake stutter gives some of her peers an excuse to make fun of her.

In *Breaking Bad*, Walter Jr. is standing outside of a convenience store with two "friends." The boys are underage and scoping out a willing adult to buy them alcohol. As the boys are repeatedly turned down, Walter Jr.'s visible crutches become a potential source of gaining sympathy. The boys seek to misuse Walter Jr.'s disability as their source of power to obtain their desired outcome. When one of the store patrons tricks them into thinking he is on board, but he is really an undercover police officer, the able-bodied boys let Walter Jr. take the fall, not caring about what might happen to him.

In both *Glee* and *Breaking Bad*, the misuse of disability for the purposes of gaining exposes the many injustices toward disabled individuals who do not have the luxury of turning their disability on and off.

Another aspect is the issue of a disabled actor versus a non-disabled actor playing the characters in these three shows and the degree of attention paid to the actual disability of these characters. In Baudrillardian terms this is the non-real becoming the real. For example, in *Glee*, Kevin McHale, an able-bodied actor, plays Artie, a paralyzed, wheelchair-bound student whose disability is featured in many of the storylines surrounding his character, making it the central focus of what he represents on the show. Also on *Glee*, the character Becky, on the other hand, is played by actress Lauren Potter, who clearly has Down syndrome. However, an actual discussion about her disability and what it entails never comes up as an issue or difficulty on the show. She represents a disability based purely on her physical appearance. In *Breaking Bad*, the actor R. J. Mitte, who plays Walter Jr., has a mild form of cerebral palsy in real life, but for the purposes of characterization, he exaggerates his disability to the degree that he needs crutches and has a more pronounced speech impediment. During the show, Walter Jr.'s character's disability is largely ignored—only the pilot episode directly represents it when Walter Jr. is made fun of in the dressing room of a clothing store while being accompanied by his parents. Finally, the character Max on *Parenthood*, played by actor Max Burkholder, is represented as having autistic spectrum disorder. Max Burkholder does not actually have this disorder, yet the storyline surrounding Max's character primarily deals with his disability and the effect it has on his family and education. A great irony is revealed when this observation is considered in the wake of Baudrillard's (1995) theory of "hyperreality." That a non-disabled actor is portraying disability as the central theme of his character and that his storyline is mainly focused on disability is a kind of hyperreality. On the other hand, the actors living with disability are not pressed to emphasize their disability on their respective shows—their disabilities are downplayed or brushed over. This state of affairs encourages the audience to believe that the non-real disabled are the real disabled and confuses the distinction between a character playing a made-up role of disability for the purposes of television with authentic disability. Baudrillard discusses "maps" and how individuals map out television, film, and other media as more realistic than real life. The characters featured on a television show become our

friends and family and are thus copies of our real selves (Baudrillard, 1981/1994). Baudrillard goes on to say it is "now impossible to isolate the process of the real, or to prove the real" (p. 21). From the perspective of including characters with disability on contemporary television, Baudrillard's interpretation of reality and how representation is implemented in these false ideologies is critical in understanding the impact that images and semiotics have on individuals.

Limitations of Particularizing a Study

While conducting any type of study, limitations will arise, and one of the first drawbacks I encountered was my limited ability to make a general assumption about the quality of the three shows I examined because my focus was specific to youth with disability (ages 9–18 years). For the purposes of time and continuity, I only examined the content of the first season of each show; therefore, the storylines in subsequent seasons featuring those characters living with disability are not included in this analysis. The main purpose of this study is to provide a substantial overview of the overarching themes, messages, and representations of youth living with disability on television. This study also delves deeper into how television transmits messages about disability during a short period of time (a season lasting a few months), which gives the audience a brief, albeit ample, look at disability and the many issues that arise for young individuals (ages 9–18) living with disability. The television programs I chose were hour-long dramas with the exception of *Glee*, which is considered a musical comedy-drama. My focus on youth with disability eliminated other television programs with characters in different age ranges living with disability.

The popular genre of reality television was not included in this study, which could be considered a limitation in that it ignored some potentially important trends associated with real youth living with disability. For example, individuals on programs such as *Little People Big World*, *The Littlest Couple*, and *The Biggest Loser* are living with disability and would be able to provide a more accurate and authentic view of living with disability on a daily basis. Future research could analyze

the portrayal of disability across a wide variety of programming types, including depictions from other countries. Another aspect of future research that could be conducted is character development in the subsequent seasons of *Glee*, *Parenthood*, and *Breaking Bad*. It is imperative to note that a global view of disability is not a stated goal of qualitative research, which seeks instead to provide an in-depth analysis of a situation. This study does not intend to provide a generalized understanding of how disability is portrayed on television; rather, it provides an analysis of how youth with disability are presented at one point in time in one popular genre of TV shows.

Chapter Eight

(Dis/Dys)abling the Truth: Findings and Implications for Pedagogy

This study was created to bring awareness to an important aspect of critical pedagogy in disability and media studies, acknowledging a void in the "big picture" and working to provoke a conversation. Linton (1998) writes that disability studies is

> A location and a means to think critically about disability, a juncture that can serve both academic discourse and social change. Disability studies provides the means to hold academics accountable for the veracity and the social consequences of their work, just as activism has served to hold the community, the education system, and the legislature accountable for disabled people's compromised social position. (pp. 1–2)

By examining how three selected television programs—*Glee, Breaking Bad,* and *Parenthood*—represent youth living with disability in an educational context, this study offers some initial insight into the impact that visual images, television, and popular culture have on our values and thus our everyday lives (Kellner, 1995). In part, the value of this study is its concern with connecting critical questions of justice and disability (e.g., how youth with disability are represented on mainstream

television), the social context (television) that helps produce our attitudes toward youth living with disability, and whether we are or can become critically conscious about the representations of disability that we consume while watching television programs focused on the representations of youth living with disability in an educational context (Kincheloe & Berry, 2004).

With respect to critical pedagogy, I am specifically concerned with what influences education from a media standpoint, how cultural norms are formulated, and what—over time—leads to unfair stereotypes or treatment of the disenfranchised in a harmful or unjust way (Freire, 1968).

The Emerging Field of Disability Pedagogy

As this study draws to a close, it is important to mention disability pedagogy, a relatively new area of study that goes deeper and looks more succinctly at disability as a social construct. Springboarding from disability studies, it is rooted in social justice, politics, and other postmodern discourses (feminist, queer, race theory). Disability pedagogy is a field starting to be recognized as important and worthy of attention from academics. Although still emerging, it is more radical in nature than disability studies, since it seeks to be more critical and raises challenges to current positions and definitions existing in the field. As much as the social model of disability and the disability acts of the 1990s raised awareness and started the discussion, disability pedagogy pushes to be more salient and eye opening. To more clearly outline the differences between the medical and social models of disability and disability pedagogy, I have adapted a chart from the worldofinclusion.com (Rieser, 2014) that focuses specifically on a school setting.

Table 8.1: Medical and social model thinking in schools

Medical Model Thinking	Social Model Thinking	Disability Pedagogy Model Thinking
Child is faulty	Child is valued	Child is approached through a critical pedagogy lens
Diagnosis	Strengths and needs defined by self and others	Influenced by critical theory, feminism, queer theory, critical race theory
Labeling	Identify barriers and develop solutions	Critiques social issues and injustices
Impairment becomes focus of attention	Outcome-based program designed	Promotes closer relationships to critical pedagogy and is fundamental to social justice
Assessment, monitoring, programs of therapy imposed	Resources are made available to ordinary services	Does not normalize or try to cure disability
Segregation and alternative services	Training for parents and professionals	Discussions, deeper analysis
Ordinary needs put on hold	Relationships nurtured	Seeks collaboration and unity
Reentry if normal enough or permanent exclusion	Diversity welcomed, child is included	Embraces differences
Society remains unchanged	Society evolves	Supports inclusion, activism, and narratives to be shared and understood

Note: This table was adapted from a chart by R. Rieser available at www.worldofinclusion.com.

The medical model of disability emphasizes the barriers and problems with various forms of disability, looking to cure rather than understand them. The social model seeks to encourage a more inclusive attitude toward disability by emphasizing the way society often hinders individuals with disability from living independent and autonomous lives. Disability pedagogy takes its cues from the social model

and the movement toward critical disability studies in education, but its true emphasis is on critical pedagogy, social justice, and postmodern philosophies of oppression and marginalization (Darder, Baltodano, & Torres, 2008).

Difficult to define but crucial to discuss, much of what is being explored in disability pedagogy comes from a variety of sources. Nocella (2008) draws from some of the more significant theorists:

1. Disability pedagogy does not believe in normalizing or equalizing. What drives this notion is capitalism, and therefore, it stands firmly against this interpretation (McLaren, 2005).
2. The social construction of categories and labeling individuals because of their differences works against disability pedagogy; recognizing and accepting differences is at its core (Fulcher, 1999).
3. The idea of inclusion (society and school) and providing access to individuals with disabilities and opportunities for them to use their voices and speak openly about their experiences is a major talking point in disability pedagogy (Ben-Moshe, Cory, Feldbaum, & Sagendorf, 2007).

Disability pedagogy focuses on inclusion and recognizes the oppressive nature of labeling and situating individuals living with disability into types that leave them voiceless and repressed. Many of the stigmas of disabled individuals associated with stereotypical labels of weakness and dependency are perpetuated by the medical model of disability, which is still a driving force behind these categorizations. Society's ongoing attempt to try to "normalize" disabled individuals makes it difficult for those living with a disability to move beyond feelings of inequality. However, other theorists such as Hughes (2002) are optimistic that in a postmodern society, differences and the concept of "otherness" will become more appreciated and a standard through which more positive portrayals of disability could be achieved (Pfeiffer, 2002).

Another critical area of disability pedagogy is the notion of affect, which Hickey-Moody and Crowley (2012) suggest works at a "micro-political" level and is the starting point of social change. They go on

to say that "[a]ffect can thus be considered an emerging point of intervention and analysis in education, pedagogy and schooling. It expresses the embodied experience of learning, the places in which we learn, the histories and desires we bring to learning" (p. 5). When considering affect within the framework of disability pedagogy/education, a shift in perception and preconceived differences is the hope and the goal. The onus is put on the student to become more aware that a body (physical) or mind (emotional/mental) does not function only in one way. According to Hickey-Moody and Crowley (2012),

> On one level, then, affect is the concept of taking something on, changing in relation to another experience or an encounter. On another level an affect is a material entity: an aesthetic compound produced in relation to particular assemblages of space-time. (p. 5)

Although this area is still developing, its emergence and gains in academia are positive motivators for those of us who are interested in this growing field of study. Linton (1998) writes:

> Disability studies is a location and a means to think critically about disability, a juncture that can serve both academic discourse and social change. Disability studies provide the means to hold academics accountable for the veracity and the social consequences of their work, just as activism has served to hold the community, the education system, and the legislature accountable for disabled people's compromised social position. (pp. 1–2)

Linton's argument supports moving forward, continuing to explore a field that was not taken seriously for so long, continuing to foster education and understanding, providing individuals with disability the opportunity to voice their concerns and be included in media and the arts, continuing to use media as a tool with which to learn and gain awareness, being advocates for those who are oppressed, and creating avenues for those who cannot fight for their rights to be heard, respected, and understood.

This study advocates using media as a way to acknowledge differences (ability, race, gender, sexual orientation, religious); it is a critical tool to educate and start a conversation particularly regarding

disability education/pedagogy. Television is reflective of the current state of culture and society (Postman, 1985). When educators refer to a study grounded in critical media and disability analysis, it can be a significant tool toward learning and understanding. An attempt to shift mindsets and misconceptions must take fundamental steps to educate teachers constructively so that they in turn can implement the language for change. This shift must start at a micro level (teacher/administrative education) and build up to a macro level (educating students, parents) by giving a voice and opportunity for expression to individuals living with disability and for disability pedagogues to share their experiences and knowledge (Ware, 2005/2009).

Mainstream methodology has a strong tendency to disregard teachers. This study seeks to explore the usefulness of breaking down a concept such as the representation of disability (youth specific) through mainstream television programs—which are highly influenced by popular culture—for the purposes of interpreting the social construction of differences. There have been many advancements of specific content that would make teaching in the area of disability education a fundamental, tactile concept to raise awareness and understanding and hopefully shift attitudes and perceptions. In a classroom setting, teaching disability critically is possible through carefully designed tasks that integrate the deconstruction of images, language, and content. By encouraging students and teachers to complete careful analysis/decoding of disability in the media (television, film, literature, Internet, advertisements) and to look for the socio/political, dominant ideological, discouraging connotations found in the term (*dis*)*ability*, we can hope for a shift to a more constructive and better understood concept.

Use of This Study in an Educational Context

The quest to influence students to think more critically and become active citizens is a never-ending endeavor and a constantly shifting dynamic between teacher and student (Giroux & McLaren, 1996). In a new era of education that seeks to model positive, critical education,

a focus on the impact of media on our lives (in the present study, on the lives of those living with disability) is crucial (Steinberg, 2011). Spotlighting representations of disability in the media through critical analysis could engage students in a dialogue about a topic rarely addressed in the educational context:

> Such critical analysis engenders a healthy and creative scepticism on the part of students. It moves them to problem-pose, to be suspicious of neutrality claims in textbooks; it induces them to look askance at, for example, oil companies' claims in their TV commercials that they are and have always been environmentally friendly organizations. (Kincheloe, Steinberg, & McLaren, 2011)

As educators become more aware of the sociopolitical, psychological, historical, and economic factors that influence curriculum and teaching practices, the movement from "traditional" (Piaget, 1969) forms of teaching to more critically cognizant approaches will help reshape the culture of the classroom. Ware (2005/2009) suggests that

> The literature emerging from disability studies offers a way "in" to appeal to educators' aesthetic sensibilities. This interdisciplinary critical genre draws from scholarship in history, literature, philosophy, anthropology, religion, medical history, and rhetoric to re-create a developed portrait of disabled people across history and cultures. (p. 103)

The evolving relationship among the various disciplines gives critical disability studies in education an opportunity to be acknowledged in the classroom and allows for teacher/student learning to further expand as a work in progress in this developing field.

Through the use of critical media popular culture studies, educators could help students become more aware of their more "unconscious" attitudes toward disability. Since disability is now featured on popular mainstream television programs, the conversation has started. One of the most important aspects of educating students on differences and stereotypes is creating a level of trust and openness in the classroom environment, and a critical analysis of television programs popular with current students would help achieve this goal.

This study is influenced greatly by critical pedagogy and critical cultural theory, which was discussed in Chapters 2 and 3 and is the

foundation for the thematic analysis in my study. Drawing from the results of this analysis, I developed Table 8.2, which illustrates some of the gaps that still linger in mainstream television representations of youth living with disabilities, aspects that need further development, and current mainstream media representations that continue to perpetuate stereotypes and misconceptions of youth living with disabilities. The table focuses on three topics of concern: positive attributes, emerging, and no change. *Positive attributes* refers to aspects that have developed and become more inclusive in their representations of youth with disability on mainstream television. *Emerging* refers to the aspects that have begun to evolve on mainstream television but are still in need of development and inclusion of disability. An example of this would be more actors living with disability being chosen to play characters with disability on television (e.g., Matt Fraser in *American Horror Story* and Peter Dinklage in *Game of Thrones*).

No change refers to the aspects that are still not evolving and continue to perpetuate stereotypes and misconceptions.

Table 8.2: Evolving attributes of disability on television

Youth with Disability Featured on Mainstream Television Attributes		
Positive Attributes	**Emerging**	**No Change**
Three television programs (*Glee, Breaking Bad, Parenthood*) dramas and musical comedies feature characters with disability	Primetime television programs (cable and broadcast) including characters with disability and differences (2009/2010)	When these television programs end, what is the status of young characters with disability featured in the mainstream?
Young characters featured (9–18 years of age)	More characters with different types of disability are appearing on television	Young characters with disability are limited in the amount of time they are featured in a storyline and are often misrepresented

Storylines promote differences and focus on inclusion (including dance/singing routines on *Glee*, Artie Abrams)	Storylines featuring characters with differences	Characters with disability are in supporting roles
Two actors out of the four actors/characters analyzed are living with disability (*Glee*, Becky Jackson, and *Breaking Bad*, Walter Jr.)	Actors hired to play roles with some form of disability	Able-bodied actors still hired to play principal roles
Some of the issues that regard schooling and education for children/ adolescents with learning differences is reflected (*Parenthood*, Max Braverman)	Emphasis on education	Characters with disability are treated poorly, disrespected by administration, misunderstood, and used as mascots (*Glee*, Becky Jackson)
There is more of an effort being made to be more inclusive of differences	Inclusive	Schools are not equipped for disability, "access for all"
Peer relationships are emphasized on *Glee* and there is a more cohesive group of individuals relating to one another	Peer relationships	Relationships seem inauthentic at times. The characters with disability are often looked upon as outcasts only relatable to other outcasts (*Glee*, Artie Abrams, and *Breaking Bad*, Walter Jr.)

Disability is used to bring an awareness to issues such as schools/buses not being wheelchair accessible (*Glee*, Artie Abrams)	Exploiting disability	In all three shows, disability is used as a means to gain things or poke fun at person/character (*Glee*, Artie Abrams, *Breaking Bad*, Walter Jr., and *Parenthood*, Max Braverman)
On *Glee*, *Breaking Bad*, and *Parenthood*, stereotypes are addressed and built around storylines attempting to deliver a message about misconceptions regarding Down syndrome, paralysis resulting in the use of a wheelchair, autism spectrum disorder, and cerebral palsy	Using stereotypical references (bullying)	Storylines are still stereotypical in nature (bullying, language used to discuss disability, exclusion of characters, social model still emphasized)

Primetime television programs (cable and broadcast) including characters with disability and differences. Due to the approach of the social model of disability (Oliver, 1983) and the Americans with Disabilities Act of 1990, television programs on the two principal U.S. broadcast television networks (NBC and Fox) and one cable network (AMC) have evolved their representations of youth living with disabilities in a more positive and inclusive direction with fewer stereotypes.

Young characters featured (9–18). The seasons (Season 1, 2009–2010) and television programs (*Glee, Breaking Bad, Parenthood*) chosen for analysis for this study all feature characters with disability between the ages of 9–18 (youth). The focus on this age range was important, since it represents a specific group often left out of television series.

Storylines featuring characters with differences. Even though the storylines of the three shows analyzed had disabled characters, these characters were not principal characters. These are emerging storylines

of youth living with disability because they include both positive moments that glorify disability and negative moments that perpetuate stereotypes of disability. For example, in *Glee*, the inclusion of Artie in musical numbers using his wheelchair as a part of a group musical performance and his role as a lead singer were positive storylines. An example of a negative storyline would be a scene in *Breaking Bad* where Walter Jr. was bullied in a dressing room because of his cerebral palsy.

Actors hired to play roles with some form of disability; able-bodied actors still hired to play principal roles. This attribute fell into both the *emerging* and *no change* categories featured on the chart. The roles of two of the four characters looked at for this study are living with Down syndrome (Becky, *Glee*) and cerebral palsy (Walter Jr., *Breaking Bad*), but the other two characters (Artie, *Glee* and Max, *Parenthood*) are played by able-bodied actors.

Emphasis on education. This attribute is *emerging* because of the nature of teachers and schools featured on the three programs. *Glee* most notably takes place in a school setting, and the role of educators is both positive and negative as they navigate the worlds of students with disability. *Parenthood* approaches education with questions and confusion regarding educational placement, and *Breaking Bad* minimally addresses education.

Inclusive. The three shows studied represent inclusive mainstream educational environments for youth living with disability. However, in *Parenthood*, Max is removed from his mainstream school when his behavior becomes disruptive to the status quo, and his parents must find him a school specifically for students with autism spectrum disorder.

Peer relationships. Peer relationships are emphasized mostly on *Glee* because it takes place primarily in a school. On *Breaking Bad* and *Parenthood*, the characters with disability are more secondary to the principal characters and storylines, so they are not featured as readily.

Exploiting disability. All three shows exploit disability through storylines that feature bullying and manipulation of the disabled character.

Using stereotypical references (bullying). Stereotypes are featured on all three programs. On *Glee*, it is implicit that the stereotypes should

be addressed and turned into valuable lessons. *Parenthood* and *Breaking Bad* address issues of stereotyping through the parents of the characters with disability.

This breakdown of the major attributes of the representations of disability on the three shows analyzed serves as a stimulus for discussions and education. The idea is to engage students to think more in depth not just about the concept of disability in general but about disabled youth specifically. The push for a more pedagogically driven learning environment seeks to pose more questions, distinguish injustices, and become more aware of the ideologies of power and dominance that shape educators' attitudes toward students living with disability. Giroux (1988) discusses the role of the critical educator: "to raise ambitions, desires, and real hope for those who wish to take seriously the issue of educational struggle and social justice" (p. 177). Keeping Giroux's statement in mind, I analyzed representations of youth with disability on television because this population of students finds itself misinterpreted and underrepresented.

The Importance of Positive Representation on Television

> The distinction between the medical and social models is of paramount importance to an understanding of the media and disability. Nearly all the problems in the representation of people with disabilities can be traced to imposition of the medical model on what would otherwise be compelling and newsworthy narratives. (Riley, 2005, p. 12)

The media reflect societal values and assume certain ideals (Hall, 1997; McLuhan, 1962; Postman, 1985). The evidence supporting the media's ability to influence the attitudes and beliefs of youth (9–18 years old) is why I chose to pursue the current study. Moreover, the media still marginalize disability by:

- Emphasizing the medical model of disability
- Focusing more on the disability than the individual/character

- Continuing to use able-bodied actors to play disabled characters on television, film, theater, etc.
- Failing to recognize the art, media, and culture produced by persons living with disabilities

From doing the analysis, I identified several outstanding questions concerning how media representations of disability are affecting real youth living with disability. Do these media representations influence how youth living with disability perceive themselves? Who are the characters with whom they identify (disabled or other)? Are the storylines and scenarios written for disabled characters accurately capturing the type of disability represented, or are the representations being overdramatized for the sake of television? These are the types of questions that could be asked for future research.

In understanding its strong effect on culture, critical pedagogy works to better approach the types of questions and areas still lacking in positive depictions being posed above. Questioning and evaluating the everyday world is what keeps critical pedagogy relevant; the questions should never stop, as there are no definitive answers (Giroux, 1983; Kincheloe, Steinberg, & McLaren, 2011).

Conclusion

This chapter outlined the significance of implementing disability education/pedagogy, a topic that is still emerging and breaking ground in the classroom. The chapter focused on the following:

1) The situations still developing in relation to youth with disability featured on mainstream television
2) The areas that have integrated more positive representations of young characters
3) The stereotypical storylines, actors, and language still in need of shifting

Looking ahead, disability studies in education is at a crossroads; it has the potential to become more integrated into critical pedagogy

and education with respect to ability and what living with differences means in a culture still dominated by ability, capitalism, political agendas, gender, race, sexual orientation, and religious beliefs. By encouraging thought-provoking questions regarding television's depiction of dramas and situation comedies produced on contemporary U.S. television programs over the last 10 years, *Glee*, *Breaking Bad*, and *Parenthood* have led to more positive and nuanced representations of characters with both physical and emotional disabilities. These representations have created discussions to broaden awareness of media challenges to the traditional medical model of disability used in the humanities and social sciences (i.e., anthropology, political science, linguistics, history, literary and cultural criticism, and critical disability studies in education), and previously held notions of disability begin to lose their force (Barnes, Mercer, & Shakespeare, 1999).

Last, this chapter explored the frameworks used in the humanities, social sciences, and critical disability studies in education as a way to more clearly understand a dynamic critical theory of disability. The deep-rooted concerns that remain around the notion of disability as an inherent, individualized, personal experience reveal how the category of disability is socially reproduced and constructed.

Series Finale: Changing Attitudes and Perceptions Through the Media

According to Riley II (2005),

> The portrayal of disability culture is the crucial barometer of much-needed so-
> cial pressure to recognize that people with disabilities are no longer children
> in need of handouts. Equality in this case arises from a little less "special"
> treatment of heroic awe—which further estranges the person with a disability
> from others—and a little more straightforward marketing. (p. 19)

The significance of a statement like the one above reflects the impor-
tance of this study as the movement toward CDSE continues to grow
and shape the way individuals approach disability as a social construct.
As I conclude this theoretical analysis of how disability is represented
on mainstream television, I (1) summarize the previous chapters, (2)
emphasize areas of optimism in education and pedagogical studies
that support the inclusion of differences, (3) speculate about future re-
search, and (4) reaffirm the purpose of the book.

Summary of Chapters

My study started with an overarching research question/statement regarding the portrayal of youth with disability on television: Although historically television drama and situation comedies produced in the United States often have failed to acknowledge the complexity of the lives of individuals living with disability, over the last decade, some contemporary U.S. television programs such as *Glee, Breaking Bad,* and *Parenthood* have created more positive and nuanced representations of characters with both physical and emotional disabilities.

I drew on the work of researchers (Barnes, 1992; Oliver, 1990; Shakespeare, 1999; Shapiro, 1999; Riley II, 2005; Ware, 2005/2009) in the discipline of disability studies to address aspects of critical disability studies in education and the representation (youth centered) of persons living with disability on mainstream television. In Chapter 1, I discussed how my experiences led to my interest in both media and CDSE. I used this chapter to ground my work and explain how I got to where I am currently as a researcher in this field. In Chapter 2, I reviewed the current and past literature relating to disability studies and disability in the media. I particularly looked at the social and medical models of disability that started a movement toward creating a broader awareness and understanding of disability as a social construct. In Chapter 3, I looked at the research relating to popular culture, television, and youth. This chapter is important because it argues in favor of the effect media has on shaping values and culture. Chapter 4 focuses on critical pedagogy in education and the saturation of media in culture and its impact on youth. These chapters are woven together to express the link between media and their impact on education and learning. In Chapters 5, 6, and 7, I used a bricolage approach and Hall's (1996) theory of encoding/decoding to analyze three mainstream television programs (*Glee, Parenthood,* and *Breaking Bad*) that feature characters between the ages of 9 and 18 who have various disabilities. Through this examination, some of the major themes involving disability (i.e., bullying, stereotypes, questions of education, inclusion, peer relationships, etc.) are brought to the surface, which helps to illustrate how

each of these shows has chosen to represent young persons living with disability and how they are treated by significant others in their lives. In Chapter 8, I provided a table that summarizes each theme, and its connection to disability (positive, emerging, or no change) is discussed to more clearly articulate the overall purpose of my research—to examine how disability is currently represented in the media, specifically three popular mainstream television programs. This concluding chapter also articulates the links between critical disability studies in education, pedagogy, and disability. The significance of using media studies and popular culture to examine messages about the representations of youth with disabilities, differences, and stereotypes is to encourage a conversation and awareness about disability and its importance in critical studies.

Optimism About the Inclusion of Differences in Education and Pedagogical Studies

As I carried out the research for this book, I had to ground my work in critical pedagogy by putting away any biases or preconceived ideas I had absorbed over the years regarding both disability and media studies. Therefore, I was always open to suggestions, to broadening my understanding, and to delving deeper into bodies of research that might have been difficult to grasp because of the intensity or explicitness of their nature to the treatment of individuals with disability over the years. As CDSE continues to grow and develop, comprehensive research and an analysis like the present study contribute to understanding the deeper social issues, (mis)conceptions, (mis)information, attitudinal barriers, and flawed ideologies relating to the treatment of disability in general. By using a methodological approach that included bricolage and a critique of popular culture and current pedagogy, I was able to draw myself closer to the demographic chosen for study— youth with disability represented on television. By analyzing the way television promotes stereotypes and preconceived notions of disability, the more fundamental themes emerged and left my study open for academic interpretation and rigor in making sense of these concepts.

Overall, I have tried to demonstrate how critical disability studies in education can benefit other areas of academia and education that currently inform critical pedagogy and other disciplines (Applebaum, 2001). Overall, I also have tried to contribute to a broader understanding of what it means to live with a disability in a culture socially constructed by dominant ideologies, which are so powerfully challenged by the following quote:

> What images of disability are most prevalent in the mass media? Television programs depicting the helpless and angry cripple as a counterpoint to a poignant story about love or redemption. Tragic news stories about how drugs or violence "ruined" someone's life by causing him or her to become disabled or even worse, stories of the heroic person with a disability who has "miraculously," against all odds, become a successful person (whatever that means) and actually inched very close to being "normal" or at least to living a normal life. Most despicable are the telethons "for" crippled people, especially, poor, pathetic, crippled children. The telethons parade young children in front of the cameras while celebrities like Jerry Lewis pander to people's goodwill and pity to get their money. In the United States surveys have shown that more people form attitudes about disabilities from telethons than from any other source. (Charlton, 2000, p. 35)

Charlton's critique was a significant point of entry that influenced my decision to pursue this study. By understanding the implications of the televised image and its impact on the social/cultural perception of disability, I hope for a shift in attitudes. Disability pedagogy works inclusively to integrate the various facets of disability into education, social justice, critical media studies, and other areas of critical pedagogy.

Ongoing Questions and Inconsistencies

Although I have found some decisive answers to my research questions, I am left with some lingering queries. For instance, what does it mean to want "disability" to be included in popular culture? Is popular culture a means by which to bridge the differences of youth with disability, or does it perpetuate stereotypes? What is the political correctness of including disability on television, and is it done to

meet an underlying agenda? The theoretical frameworks that McRuer (2003) uses to analyze politics may be helpful for future research that hopes to understand the significance of disability in the current social/political environment. Haller and Ralph (2006) also raise the topic of consumerism and advertising in relation to individuals with disability as a means to promote capitalism and perpetuate an overall economic agenda. As an able-bodied person critiquing representations of disability in the media, I have worked hard to not be demeaning or belittling. I carefully chose the literature, articles, television programs, and theories pertaining to my topic, and I used a critical studies approach to analyze the data. In the first chapter, I reflected on the experiences I had with disability at a young age: my relationship with my grandmother who had an amputation. I also discussed the effect this had on me, our family, and, most importantly, my grandmother. As someone who comes from a background in media studies and inclusive education, I am able to be more reflexive about potential hidden meanings, messages, and biases existing in a media-centered study. The deep-rooted concerns that remain around the notion of disability as an inherent, individualized, personal experience reveal how the category of disability is socially reproduced and constructed.

The contemporary models of representation and identity formation discussed in this thesis help underpin the more global interpretations of disability and the understanding of ability or "ableism." According to Riley (2005), "One of the reasons the representation of people with disabilities in the press is such a fascinating problem is due to the complexities posed by this question of identity" (p. 19). Thus, representation is not the only concept in need of critique; we also should look at how the representation of differences is reinforced and produced so that new meanings and more distinctive depictions and discussions of disability can be created and observed. These concerns are the crux of this thesis, which in essence has focused on deconstructing and bringing awareness to the current forms of representations of disability while paying careful attention to the politics and educational composition of these representations.

In unpacking such a complex and multifaceted topic, the key arguments that must be grappled with in future studies of disability within

media and popular culture are those that deal with power, perception, and ability versus (dis)ability. Scholars contributing to the fields of CDSE, media studies, critical pedagogy, and education have taken the necessary steps to drive discussions, start movements, and interpret the past, current, and future direction of disability and critical media studies. Activists such as Stella Young (2014) have propelled the conversations we have about the social construct of disability and society's perception into a new realm of possibilities and understanding. She states:

> I really want to live in a world where disability is not the exception, but the norm. I want to live in a world where a 15-year-old girl sitting in her bedroom watching "Buffy the Vampire Slayer" isn't referred to as achieving anything because she's doing it sitting down. I want to live in a world where we don't have such low expectations of disabled people that we are congratulated for getting out of bed and remembering our own names in the morning. I want to live in a world where we value genuine achievement for disabled people, and I want to live in a world where a kid in year 11 in a Melbourne high school is not one bit surprised that his new teacher is a wheelchair user. Disability doesn't make you exceptional, but questioning what you think you know about it does. (Young, 2014, 8:17/9:01)

Young and others with similar sentiments have inspired my work and have encouraged me to question, discuss, explore, and monitor the various types of theories and contexts pertaining to the complexity of this multifaceted discourse. I will continue to seek out the gaps and inconsistencies, but I will also look toward the positive, the evolution of a discipline that has been misrepresented for so long and that continues to grow.

Notes

1. http://undesadspd.org/youth/resourcesandpublications/youthwithdisabilities.aspx
2. http://www.childwelfare.gov/organizations/search.cfm
3. www.ADA.gov

References

Abram, D. (1996). *The spell of the sensuous: Perception and language in a more-than-human world*. New York: Pantheon.

Adorno, T. W., & Horkheimer, M. (1972). *Dialect of enlightenment* (J. Cumming, Trans.). New York: Seabury Press.

Albrecht, G., Seelman, K., & Bury, M. (2001). *Handbook of critical disability studies in education*. Thousand Oaks, CA: Sage.

American Academy of Adolescent and Child Psychiatry. (2011). *Children and watching TV, "Facts for families."* No. 54, 12/11. Retrieved from http://www.aacap.org

American Academy of Pediatrics, Council on Communications and Media. (2013). Children, adolescents, and the media. *Pediatrics, 132,* 958–961. Retrieved from http://pediatrics.aappublications.org/content/early/2013/10/24/peds.2013-2656.full.pdf+html

Americans with Disabilities Act of 1990, Pub. L. No. 101–336, 104 Stat. 328. (1990).

American Psychological Association. (2014). Bullying and School Climate. Retrieved from http://www.apa.org/about/gr/issues/cyf/bullying-school-climate.aspx

Amundson, R. (1992). Disability, handicap, and the environment. *Journal of Social Philosophy, 23*(1), 105–119.

Applebaum, B. (2001). Raising awareness of dominance: Does recognising dominance mean one has to dismiss the values of the dominant group? *Journal of Moral Education, 30*(1), 55–70.

Arad, A., Foster, G., Milchan, A. (Producer), & Johnson, S. M. (Director). (2003). *Daredevil* [Motion picture]. USA: 20th Century Fox Home Entertainment.

Barnes, C. (1991). *Disabled people in Britain and discrimination: A case for anti-discrimination legislation*. London, UK: Hurst and Co.

Barnes, C. (1992). *Disabling imagery and the media: An exploration of media representations of disabled people*. Belper, UK: British Council of Organisations of Disabled People.

Barnes, C. (1996). The social model of disability: Myths and misrepresentations. *Coalition: Magazine of the Greater Manchester Coalition of Disabled People*. Manchester, UK: Greater Manchester Coalition of Disabled People, August: 25–30.

Barnes, C., & Mercer, G. (2003). *Disability*. Cambridge, UK: Polity Press.

Barnes, C., Mercer, G., & Shakespeare, T. (1999). *Exploring disability: A sociological introduction*. Cambridge, UK: Polity Press.

Barnhart, R. K. (1988). Handicap. In *Chambers dictionary of etymology* (pp. 463–464). New York: Chambers.

Barrie, J. (1911). *Peter Pan*. (Lit2Go ed.). Retrieved from http://etc.usf.edu/lit2go/86/peter-pan/

Barthes, R. (1964). *Elements of semiology*. New York: Hill and Wang.

Barthes, R. (1975). *The pleasure of the text* (R. Miller, Trans.). New York: Hill and Wang.

Barthes, R. (1992). The structuralist activity. In H. Adams (Ed.), *Critical theory since Plato* (Rev. ed.; pp. 1128–1133). New York: Harcourt Brace Jovanovich.

Baudrillard, J. (1994). *Simulacra and simulation*. (S. Glaser, Trans.). East Lansing University of Michigan Press. (Original work published 1981)

Baudrillard, J. (2003). *Passwords*. (C. Turner, Trans). New York: Verso.

Baudrillard, J. (2010). *America*. (reprint ed.). Paris: Verso.

Ben-Moshe, L., Cory, R. C., Feldbaum, M., & Sagendorf, K. (2007). *Building pedagogical curb cuts: Incorporating disability in the university classroom and curriculum*. Syracuse, NY: Syracuse University Press.

Berry, G. L., & Asamen, J. K. (Eds.). (1993). *Children and television: Images in a changing sociocultural world*. Newbury Park, CA: Sage.

Berry, K. S., & Kincheloe, J. L., (2004). *Rigour and complexity in educational research*. London: Open University Press.

Betts, R. (2004). *A history of popular culture: More of everything, faster and brighter*. New York: Routledge.

Beyer, B. K. (1988). *Developing a thinking skills program*. Boston, MA: Allyn & Bacon.

Bourdieu, P. (1984). *Distinction: A social critique of the judgement of taste*. London, UK: Routledge.

Boyatz, R. E. (1998). *Transforming qualitative information: Thematic analysis and code development*. Thousand Oaks, CA: Sage.

Braun, V., & Clarke, V. (2006). Using thematic analysis in psychology. *Qualitative Research in Psychology, 3*(2), 77–101.

Brottman, M. (2005). *High theory/low culture*. New York: Palgrave Macmillan.

Bulkley, K. (2011). The impact of Twitter on TV shows. *The Guardian*. Retrieved from http://www.theguardian.com/film/2011/jun/06/twitter-facebook-television-shows

Butler-Kisber, L. (2010). *Qualitative inquiry: Thematic, narrative and arts-informed perspectives*. Thousand Oaks, CA: Sage.

Carroll, M. T., & Tafoya, E. (2000). *Phenomenological approaches to popular culture*. Bowling Green, OH: Bowling Green State University Popular Press.

Charlton, J. (2000). *Nothing about us without us: Disability, oppression and empowerment*. Berkeley University of California Press.

Clapton, J., & Fitzgerald, J. (1997). The history of disability: A history of "otherness." In *New Renaissance: A J. Soc. Spiritual Awakening*. London 1–7.

Clogston, J. (1990). *Disability coverage in 16 newspapers*. Louisville, KY: Avocado Press.

Clogston, J. S. (1992). *Fifty years of disability coverage in the New York Times*. Paper presented to the Association for Education in Journalism and Mass Communication. Montreal, Quebec.

Clogston, J. S. (1993). *Changes in coverage patterns of disability issues in three major American newspapers, 1976–1991*. Paper presented to the Association of Education in Journalism and Mass Communication. Kansas City, MO.

Cook, D. (1996). *The culture industry revisited: Theodor Adorno on mass culture*. Lanham, MD: Rowman and Littlefield.

Cook, J. A. (2001). Sexuality and people with psychiatric disabilities. *SIECUS Report, 29*(1), 20–25.

Corker, M. (1999). "Disability": The unwelcome ghost at the banquet... and the conspiracy of "normality." *Body and Society, 5*(4), 75–83.

Corker, M., & Shakespeare, T. (2002). *Disability/postmodernity: Embodying disability theory*. London, UK: Continuum.

Crow, L. (1996). Including all of our lives: Renewing the social model of disability. In C. Barnes & G. Mercer (Eds.), *Exploring the divide: Illness and disability* (pp. 55–73). Leeds, UK: Disability Press.

Dahl, M. (1993). The role of the media in promoting images of disability—Disability as metaphor: The evil crip. *Canadian Journal of Communication, 18*(1). Retrieved from http://cjconline.ca/index.php/journal/article/view/718/624

Danforth, S., & Gabel, S. (2006). *Vital questions facing critical disability studies in education in education*. New York: Peter Lang.

Darder, A., Baltodano, M., & Torres, R. D. (2008). *Critical pedagogy reader: Theory and practice* (2nd ed.). New York: Routledge.

Darke, P. (2004). The changing face of representations of disability in the media. In J. Swain, S. French, & C. Barnes (Eds.), *Disabling barriers—Enabling environments* (pp. 100–106). London: Sage.

Davies, J. (1996). *Educating students in a media-saturated culture*. Lancaster, PA: Technomic.

Davis, L. (2013). *The critical disability studies in education reader*. New York: Routledge.

Denzin, N. K., & Lincoln, Y. S. (2000). Introduction: The discipline and practice of qualitative research. In N. K. Denzin & Y. S. Lincoln (Eds.), *Handbook of qualitative research* (2nd ed., pp. 1–29). Thousand Oaks, CA: Sage.

Derrida, J. (1976). *Of grammatology*. (G. Spivak, Trans.). Baltimore, MD: Johns Hopkins University Press. (Originally published 1967)

Dickens, C. (1843). *A Christmas carol*. London, UK: Chapman & Hall.

Doob, C. B. (1994). *Sociology: An introduction*. Boston, MA: Harcourt.

Dorr, A., & Rabin, B. E. (1995). Parents, children, and television. In M. H. Bornstein (Ed.), *Handbook of parenting, Vol. 4: Applied and practical considerations of parenting* (pp. 323–357). Hillsdale, NJ: Erlbaum.

Douglas, K., & Jaquith, D. (2009). *Engaging learners through artmaking: Choice-based art education in the classroom*. New York: Teachers College Press.

Dowker, A. (2004). The treatment of disability in 19th and early 20th century. *Disability Studies Quarterly, 24*(1). www.dsq-sds.org

du Gay, P. (1990). *The values of bureaucracy*. New York: Oxford.

du Gay, P. (1997). Organizing identity: Making up people at work. In P. du Gay (Ed.), *Production of culture/cultures of production* (pp. 285–345). Thousand Oaks, CA: Open University.

du Gay, P., Hall, S., James, L., Mackay, H., & Negus, K. (1997). *Doing cultural studies: The story of the Sony Walkman*. Thousand Oaks, CA: Open University.

Durkheim, É. (1960). The dualism of human nature and its social conditions. In K. H. Wolff (Ed.), *Essays on sociology and philosophy* (pp. 325–340). New York: Harper & Row.

Ebb, F., & Kandor, J. (1979). New York, New York. [Recorded by F. Sinatra]. On *Trilogy: Past, present future* [CD]. New York: Reprise Records.

Estes, A., Dawson, G., Koehler, E., Zhou, X-H., & Abbott, R. (2009). Parenting stress and psychological functioning among mothers of preschool children with autism and developmental delay. *Autism: The International Journal of Research and Practice, 13*(4), 375–387. doi:10.1177/1362361309105658

Evans, J., & Hall, S. (1999). *Visual culture: The reader*. London: Sage Publications.

Fiske, J. (1989). *Understanding popular culture*. London: Routledge.

Flecha, R., Gomez, J., & Puigvert, L. (2003). *Contemporary sociological theory*. New York: Peter Lang.

Foucault, M. (1984). *The Foucault reader*. New York: Random House.

Foucault, M. (1991). *Discipline and punish: The birth of the prison*. London, UK: Penguin.

Foucault, M. (1992). The use of pleasure. *The history of sexuality: Volume two*. (Trans R. Hurley). Harmondsworth, UK: Penguin.

Freire, P. (1970). *Pedagogy of the oppressed*. New York: Herder and Herder.

French, S. (1993). Disability, impairment or something in-between. In J. Swain, V. Finkelstein, S. French, & M. Oliver (Eds.), *Disabling barriers—Enabling environments* (pp. 17–25). London: Sage.

Freud, S. (1923). The ego and the id. *The standard edition of the complete psychological works of Sigmund Freud, volume XIX (1923–1925): The ego and the id and other works* (pp. 1–66). London: Hogarth Press and the Institute of Psycho-Analysis.

Fu, V. (2003). *Multiculturalism in early childhood programs: Culture, schooling, and education in democracy*. Retrieved from http://ecap.crc.illinois.edu/eecearchive/books/multicul/fu.html

Fulcher, G. (1999). *Disability policies? A comparative approach to education policy*. Sheffield, UK: Philip Armstrong.

Gabel, S. (2001). I wash my face with dirty water. Narratives of disability and pedagogy. *Journal of Teacher Education, 52*(1), 31–47.

Gabel, S. (2004). Education and disability studies. *Disability Studies Quarterly, 24*(2). www.dsq-sds.org

Gabel, S. (2005/2009). Introduction: Critical disability studies in education in education. In S. Gabel (Ed.), *Critical disability studies in education* (pp. 1–21). New York: Peter Lang.

Gabel, S. (2006). Deciding who get to decide. *Disability Studies Quarterly, 26*(2). www.dsq-sds.org

Gabel, S., & Connor, D. (2009). Theorizing disability: Implications and applications for social justice in education. In W. Ayers, T. Quinn, & D. Stovall (Eds.), *Handbook of social justice* (pp. 377–399). New York: Lawrence Erlbaum.

Gardner, J. M., & Radel, M. (1978). Portrait of the disabled in the media. *Journal of Community Psychology, 6*(3), 269–274.

Garland-Thomson, R. (2009). *Staring: How we look.* New York: Penguin.

Garrison, M. (Producer). (1965). *Wild, wild, West.* [Television Program]. Los Angeles: CBS.

Gauntlett, D. (2002/2008). *Media, gender and identity: An introduction.* London: Routledge.

Gebner, G., Gross, L., Morgan, M., Signorielli, N., & Shanahan, J. (2002). Growing up with television: Cultivation processes. In J. Bryant & D. Zillmann (Eds.), *Media effects: Advances in theory and research* (2nd ed., pp. 43–67). Mahwah, NJ: Lawrence Erlbaum.

Gilligan, V. (Producer). (2008). *Breaking bad.* [Television series]. Santa Monica, CA: High Bridge.

Giroux, H. A. (1983). *Critical theory and educational practice.* Australia: Deakin University Press.

Giroux, H. A. (1988). *Teachers as intellectuals: Toward a critical pedagogy of learning.* South Hadley, MA: Bergin Garvey.

Giroux, H. A. (2001). Culture, power and transformation in the work of Paulo Freire. In F. Schultz (Ed.), *SOURCES: Notable selections in education* (3rd ed., pp. 77–86). New York: McGraw-Hill Dushkin.

Giroux, H. A., & McLaren, P. (1996). Teacher education and the politics of engagement: The case for democratic schooling. In P. Leistyna, A. Woodrum, & S. A. Sherblom (Eds.), *Breaking free: The transformative power of critical pedagogy* (pp. 301–331). Cambridge, MA: Harvard Educational Review.

Glouberman, M. (Producer). (2000). *Malcolm in the middle* [Television series]. Los Angeles: Fox.

Goggin, G., & Newell, C. (2003). *Digital disability: The social construction of disability in new media.* Lanham, MD: Rowman & Littlefield.

Goodley, D. (2011). *Critical disability studies in education: An interdisciplinary introduction.* London, UK: Sage.

Gramsci, A. (1971). *Selections from the prison notebooks of Antonio Gramsci.* New York: International Publishers.

Griffen, M. (1975). *Wheel of fortune.* [Television program]. Los Angeles: CBS.

Guest, G., MacQueen, K., & Namey, E. (2012). Introduction to applied thematic analysis. In G. Guest, K. MacQueen, & E. Namey (Eds.), *Applied thematic analysis* (pp. 3–21). Thousand Oaks, CA: Sage.

Hahn, H. (2010). The politics of physical differences: Disability and discrimination. *Journal of Social Issues, 41*(1), 39–47.

Hall, S. (1981). Notes on deconstructing the popular. In Raphael Samuel (Ed.), *In people's history and socialist theory* (pp. 410–417). London: Routledge.

Hall, S. (1992). Cultural studies and its theoretical legacies. In L. Grossberg, C. Nelson, & P. Treichler (Eds.), *Cultural studies* (pp. 277–294). New York: Routledge.

Hall, S. (1996). Introduction: Who needs "identity"? In J. Rutherford (Ed.), *Cultural identity in question* (pp. 1–17). London: Lawrence and Wishart.

Hall, S. (Ed.) (1997). *Representation: Cultural representations and signifying practices.* London: Sage.

Hall, S. (2006). Encoding/decoding. In M. G. Durham & D. M. Kellner (Eds.), *Media and cultural studies: Keyworks* (pp. 163–173). Malden, MA: Blackwell.

Hall, S. [n.d.] *Representation & the media: Featuring Stuart Hall.* [YouTube video]. Retrieved from http://www.youtube.com/watch?v=aTzMsPqssOY

Hall, S., Evans, J., & Open University. (1999). *Visual culture: The reader.* London: Sage.

Haller, B. (1995). Rethinking models of media representation of disability. *Critical Disability Studies in Education Quarterly, 15*(2), 26–30.

Haller, B. (2006). Are disability images in advertising becoming bold and daring? *Disability Studies Quarterly, 26*(3).

Haller, B. (2010). *Representing disability in an ableist world: Essays on mass media.* Louisville, KY: Avocado Press.

Haller, B., & Ralph, S. (2006). Are disability images in advertising becoming bold and daring? An analysis of prominent themes in US and UK campaigns. *Critical Disability Studies in Education Quarterly, 26*(3).

Halloran, J. D. (1981). The context of mass communication research. In E. McAnany, J. Schnitman, & N. Janus (Eds.), *Communication and social structure: Critical studies in mass media research* (pp. 21–57). New York: Praeger.

Handel, J. (2011). *Hollywood on strike!: An industry at war in the Internet age.* Los Angeles: Hollywood Analytics.

Hasler, F. (1993) Developments in the disabled people's movement. In J. Swain, V. Finkelstein, S. French, & M. Oliver (Eds.), *Disabling barriers, enabling environments* (pp. 278–283). London, UK: Sage.

Hastings R. P., Kovshoff, H., Ward, N. J., deqli Espinosa, F., Brown, T., & Remington, B. (2005). Systems analysis of stress and positive perceptions in mothers and fathers of pre-school children with autism. *Journal of Autism and Developmental Disorders, 35*, 635–644.

Hebdige, D. (1979). *Subcultures: The meaning of style.* London: Methuen.

Hickey-Moody, A., & Crowley, V. (2012). Introduction: Disability matters: Pedagogy, media and affect. In A. Hickey-Moody & V. Crowley (Eds.), *Disability matters: Pedagogy, media and affect* (pp. 1–11). Oxon, UK: Routledge.

Hiles, D. R. (2006). Theorizing human diversity: A human science perspective. Paper presented at 25th International Human Science Research Conference, August, 2006, Pleasant Hill, CA.

Hobbs, R. (1998). The seven great debates in the media literacy movement. *Journal of Communication, 48*, 16–32. doi:10.1111/j.1460-2466.1998.tb02734.x

Hoechsmann, M., & Low, B. (2008). *Reading youth writing: New literacies, cultural studies and education.* New York: Peter Lang.

Houston, B. (2000). Viewing television: The metapsychology of endless consumption. In M. T. Caroll & E. Tafoya (Eds.), *Phenomenological approaches to popular culture* (pp. 183–195). Bowling Green, OH: Bowling Green State University Popular Press.

Hughes, B. (2005). What can a Foucauldian analysis contribute to disability theory? In S. Tremain (Ed.), *Foucault and the government of disability* (pp. 78–92). Ann Arbor University of Michigan Press.

Hughes, W. (2002). Baumen's strangers: Impairments and the invalidation of disabled people in modern and post-modern cultures. *Disability and Society, 17*(5), 571–584.

Huntemann, N., & Morgan, M. (2001). Handbook of children and the media. In D. Singer & J. Singer (Eds.), *Mass media and identity development* (pp. 309–323). Thousand Oaks, CA: Sage.

Husserl, E. (1982). *Ideas pertaining to a pure phenomenology and to a phenomenological philosophy: First book: General introduction to a pure phenomenology* (F. Kersten, Trans.). The Hague, Netherlands: Nijhoff. (Originally published 1913)

Huston, A. C., Donnerstein, E., Fairchild, H., Feshbach, N. D., Katz, P. A., Murray, J. P., Rubinstein, E. A., Wilcox, B. L., & Zuckerman, D. (1992). *Big world, small screen: The role of television in American society.* Lincoln, University of Nebraska Press.

Jenkins, H. (2006). *Convergence culture.* New York: New York University Press.

Jhally, S., & Lewis, J. (1992). *Enlightened racism:* The Cosby Show, *audiences, and the myth of the American dream.* Boulder, CO: Westview Press.

Johnson, S. (2006). *Everything bad is good for you.* New York: Penguin.

Johnstone, C. (2004). Disability and identity: Personal constructions and formalized supports. *Critical Disability Studies in Education Quarterly, 24*(4). Retrieved from http://dsq-sds.org/article/view/880/1055

Kaiser Family Foundation. (2010). Daily media use among children and teens up dramatically from five years ago. Retrieved from http://kff.org/disparities-policy/press-release/daily-media-use-among-children-and-teens-up-dramatically-from-five-years-ago/

Katmis, J. (producer). (2010). *Parenthood* [Television series]. Los Angeles: Universal Television.

Kellner, D. (1995). *Media culture: Cultural studies, identity, and politics between the modern and the postmodern.* London, UK: Routledge.

Kellner, D. (2000). Multiple literacies and critical pedagogies: New paradigms. In P. Trifonas (Ed.), *Revolutionary pedagogies: Cultural politics, education and discourse theory* (pp. 196–225). London, UK: Routledge.

Kellner, D. (2003a). *Media culture: Cultural studies, identity and politics between the modern and the postmodern*. London, UK: Routledge.

Kellner, D. (2003b). Jean Baudrillard. In G. Ritzer (Ed.), *The Blackwell companion* (pp. 310–333). Oxford, UK: Blackwell.

Kellner, D., & Share, J. (2007). *Critical media literacy, democracy, and the reconstruction of education*. In D. Macedo & S. Steinberg (Eds.), *Media literacy: A reader* (pp. 3–23). New York: Peter Lang.

Kincheloe, J. L. (2001). Describing the bricolage: Conceptualizing a new rigor in qualitative research. *Qualitative Inquiry, 7*(6), 679–692.

Kincheloe, J. L. (2005a). On to the next level: Continuing the conceptualization of the bricolage. *Qualitative Inquiry, 11*(3), 323–350.

Kincheloe, J. L. (2005b). *Critical constructivism*. New York: Peter Lang.

Kincheloe, J. (2008). Critical pedagogy and the knowledge wars of the twenty-first century. *International Journal of Critical Pedagogy* [Electronic version], *1*(1), 1–22. Retrieved from http://freireproject.org/wp-content/journals/TIJCP/Vol1No1/48–38–1-PB.pdf

Kincheloe, J., & McLaren, P. (2008). Rethinking critical theory and qualitative research. In N. Denzin & Y. Lincoln (Eds.), *The landscape of qualitative research* (pp. 403–457). Thousand Oaks, CA: Sage.

Kincheloe, J. L., Steinberg, S. R., & McLaren, P. (2011). Critical theory, critical pedagogy, and qualitative research. In N. Denzin & Y. Lincoln (Eds.), *The Sage handbook of qualitative research* (pp. 163–177). Thousand Oaks, CA: Sage.

Kirkorian, H. L., Wartella, E. A., & Anderson, D. R. (2008). Media and young children's learning. *Futureofchildren.org, 18*(1), 39–61. Retrieved from https://www.princeton.edu/futureofchildren/publications/docs/18_01_03.pdf

Klages, M. (2001). Structure, sign, and play in the discourse of the human sciences. Retrieved from http://www.webpages.uidaho.edu/~sflores/KlagesDerrida.html

Kroeber, L., & Kluckhohn, C. (1952). *Culture: A critical review of concepts and definitions*. New York: Random House.

Leavitt, R., & Moye, M. G. (Producers). (1987). *Married with children*. [Television program]. Los Angeles: Fox Network.

Leder, D. (1990). *The absent body*. Chicago, IL: University of Chicago Press.

Lemesianou, C., & Grinberg, J. (2006). Criticality in education research. In K. Tobin & J. Kincheloe (Eds.), *Doing educational research: A handbook* (pp. 211–233). Rotterdam, The Netherlands: Sense.

Lévi-Strauss, C. (1962). *The savage mind*. London, UK: Weidenfeld and Nicolson.

Lin, C. A., & Atkin, D. (1989). Parental mediation and rulemaking for adolescent use of television and VCRs. *Journal of Broadcasting & Electronic Media, 33*, 53–67.

Linton, S. (1998). *Claiming disability: Knowledge and identity*. New York: New York University Press.

Longmore, P. (2003). Screening stereotypes: Images of disabled people in television and motion pictures. In P. Longmore (Ed.), *Why I burned my book and other essays on disability* (pp. 131–146). Philadelphia, PA: Temple University Press.

Lukes, S. (1974). *Power: A radical view.* New York: Macmillan.

MacFarlane, S. (Producer). (1999). *Family guy.* [Television program]. Los Angeles: Fox.

McLaren, P. (2005). *Capitalists & conquerors: A critical pedagogy against empire.* Lanham, MD: Rowman & Littlefield.

McLaren, P. (2006). *Life in schools: An introduction to critical pedagogy in the foundations of education* (5th ed.). Boston, MA: Allyn and Bacon.

McLuhan, M. (1962). *The Gutenberg galaxy: The making of typographic man.* Toronto, ON: University of Toronto Press.

McLuhan, M. (1964). *Understanding media: The extensions of man.* Cambridge, MA: MIT Press.

McLuhan, M. (1967/1994). *The medium is the massage: An inventory of effects.* New York: Bantam.

McLuhan, M. (1995). *The essential Marshall McLuhan.* E. McLuhan & F. Zingrone (Eds.). Don Mills, ON: Anansi.

McLuhan, M., Fiore, Q., & Agel, J. (1994). *The medium is the massage: An inventory of effects.* New York, NY: Bantam Books.

McRuer, R. (2003). As good as it gets: Queer theory and critical disability. *GLQ: A Journal of Lesbian and Gay Studies, 9*(1), 79–105. Retrieved from http://muse.jhu.edu/journals/journal_of_lesbian_and_gay_studies/summary/v009/9.1mcruer02.html

McRuer, R. (2006). We were never identified: Feminism, queer theory, and a disabled world. *Radical History Review, 94,* 148–154.

Media Literacy Project. (n.d.). Introduction to media literacy. Retrieved from http://opi.mt.gov/pdf/tobaccoed/IntroMediaLiteracy.pdf

Merleau-Ponty, M. (1962/2005). *Phenomenology of perception.* (F. Williams & D. Gurriere, Trans.). London, UK: Routledge.

Merrin, W. (2005). *Baudrillard and the media.* Cambridge, UK: Polity Press.

Mittell, J. (2004). A cultural approach to television genre theory. In R. C. Allen & A. Hill (Eds.), *The television studies reader* (pp. 171–181). London: Routledge.

Morley, D., & Chen, K.-H. (Eds.). (2006). *Stuart Hall: Critical dialogues in cultural studies.* London: Routledge.

Morris, J. (1989). *Able lives: Women's experience of paralysis.* London: Women's Press.

Murphy, R. (Producer). (2009). *Glee.* [Television series]. Los Angeles: Brad Falchuk Teley-Vision, Ryan Murphy Productions, 20th Century Fox Television.

Nabi, R., & Riddle, K. (2008). Personality traits, television viewing and the cultivation effect. *Journal of Broadcasting & Electronic Media, 52*(3), 327–348.

National Institute of Child Health and Human Development. (2014). Autism spectrum disorder. Retrieved from http://www.nimh.nih.gov/health/topics/autism-spectrum-disorders-asd/index.shtml

National Library of Medicine. (n.d.). Gangrene. Retrieved from https://www.nlm.nih.gov/medlineplus/gangrene.html

Niebuhr, K. E., & Niebuhr, R. E. (1999). An empirical study of student relationships and academic achievement. *Education, 119*(4), 679–682.

Nielsen Media Research. (2012). TV measurement. Retrieved from http://www.nielsen.com/us/en/nielsen-solutions/nielsen-measurement/nielsen-tv-measurement.html

Nixon, A. (Producer). (1970). *All my children*. [Television program]. New York/Los Angeles: American Broadcasting Company.

Nocella, A. J., II. (2008). Emergence of disability pedagogy. *Journal for Critical Education Policy Studies, 6*(2), 77–94.

Oliver, M. (1983). *Social work with disabled people*. Basingstoke, UK: Macmillan.

Oliver M. (1990). *The politics of disablement*. Basingstoke, UK: Macmillan.

Oliver, M. (1996). *Understanding disability: From theory to practice*. Houndmills, UK: Palgrave.

Overboe, J. (1999). "Difference in itself": Validating disabled people's lived experience. *Body and Society, 5*(4), 17–29.

Parker, T., & Stone, M. (Producer). (1997). *South park*. [Television program]. New York: Comedy Central.

Parsons, T. (1951). *The social system*. New York: Free Press.

Pernick, M. S. (1996). *The black stork: Eugenics and the death of "defective" babies in American medicine and motion pictures since 1915*. New York: Oxford University Press.

Pfeiffer, D. (2002). A comment on the social model(s). *Critical Disability Studies in Education Quarterly, 22*(4), 234–235.

Piaget, J., & Inhelder, B. (1969). *The psychology of the child*. New York: Basic Books.

Pointon, A., & Davies, C. (Eds.). (1997). *Framed: Interrogating disability in the media*. London: BFI Publishing.

Postman, N. (1979). *Teaching as a conserving activity*. New York: Delacorte Press.

Postman, N. (1982). *The disappearance of childhood*. New York: Vintage/Random House.

Postman, N. (1985). *Amusing ourselves to death: Public discourse in the age of television*. New York: Penguin.

Postman, N. (1985, December 4). Commentary: Learning in the age of television. *Education Week*. Retrieved from http://www.edweek.org/ew/articles/1985/12/04/06120030.h05.html

Postman, N. (1994). *The disappearance of childhood*. New York: Random House.

Quetelet, A. (1968). Adolphe Quetelet. *International encyclopedia of the social sciences*. Retrieved from http://www.encyclopedia.com/doc/1G2-3045001026.html

Rabinow, P. (Ed.). (1984). *The Foucault reader*. New York: Random House.

Resnais, A. (Director). (1955). *Night and fog*. [Film]. France: Argos Films.

Richardson, T. (2012). *The rise of youth counter culture after World War II and the popularization of historical knowledge: Then and now*. Paper presented at the Historical Society Annual Meeting May 2012, Columbia, SC.

Rieber, R. W., & Carton, A. S. (Eds.). (1987). *The collected works of L. S. Vygotsky: Vol. 1. Problems of general psychology*. New York: Plenum.

Rieser, R. (2014). Social and medical models of disability. Retrieved from http://www.worldofinclusion.com

Riff, D., Lacy, S., & Fico, F. (2014). *Analyzing media messages: Using quantitative content analysis in research* (3rd ed.). London, UK: Routledge.

Riley, C., II. (2005). *Disability and the media: Prescriptions for change.* Lebanon, NH: University Press of New England.

Rioux, M., & Bach, M. (1994). *Disability is not measles: New research paradigms in disability.* Toronto, ON: Roeher Institute York University.

Rodrigue, J. R., Morgan, S. B., & Geffken, G. (1990). Families of autistic children: Psychosocial functioning of mothers. *Journal of Clinical Child Psychology, 19,* 371–379.

Roper, L. (2003). Disability in media. *The Media Education Journal.* Retrieved from http://www.mediaed.org.uk/posted_documents/DisabilityinMedia.html

Rosenblum, P. (1981). The popular culture and art education. *Art Education, 34*(1), 8–11.

Ross, K. (1997). But where's me in it?: Disability, broadcasting and the audience: Commentary. *Media Culture and Society, 19*(4), 669–677.

Rothenberg, P. (1998). The construction, deconstruction, and reconstruction of difference. In L. Harris (Ed.), *Racism* (pp. 281–296). Amherst, NY: Humanity Books.

Rousseau, J. (1979). *Émile or on education.* (A. Bloom, Trans.). New York: Basic Books.

Saad, L. (2013). TV is Americans' main source of news: Preferred news source varies by age, education, and politics, among other factors. Retrieved from http://www.gallup.com/poll/163412/americans-main-source-news.aspx

Sandahl, C., & Auslander, P. (2005). *Bodies in commotion: Disability and performance.* Ann Arbor: University of Michigan Press.

Sanders, J. L., & Morgan, S. B. (1997). Family stress and management as perceived by parents of children with autism or Down syndrome: Implications for intervention. *Child and Family Behavior Therapy, 19,* 15–32.

Sandlin, J. A., O'Malley, M. P., & Burdick, J. (2011). Mapping the complexity of public pedagogy scholarship: 1894–2010. *Review of Educational Research, 81*(3), 338–375.

Sardar, Z., & Van Loon, B. (2010). *Introducing cultural studies: A graphic guide.* London, UK: Totem Books.

Schacter, D. L. (2011). *Psychology* (2nd ed.). New York: Worth Publishers.

Schwandt, T. A. (2001). *Dictionary of qualitative inquiry.* Thousand Oaks, CA: Sage.

Schwoch, J., White, M., & Reilly, S. (1992). *Media knowledge: Readings in popular culture, pedagogy, and critical citizenship.* Albany State University of New York Press.

Shakespeare, T. (1999). Art and lies? Representations of disability on film. In M. Corker & S. French (Eds.), *Disability discourse* (pp. 164–172). Buckingham, UK: Open University Press.

Shakespeare, T., & Watson, N. (2002). The social model of disability: An outmoded ideology. *Research in Social Science and Disability, 2,* 9–28.

Shapiro, A. (1999). *Changing negative attitudes toward classmates with disabilities.* New York: Routledge.

Shapiro, J. (1993). *No pity: People with disabilities forging a new civil rights movement.* New York: Random House.

Share, J. (2009). *Media literacy is elementary: Teaching youth to critically read and create.* New York: Peter Lang.

Siebers, T. (2008). *Disability theory.* Ann Arbor University of Michigan Press.

Simpson, B. (2004). *Children and television.* London: Bloomsbury.

Smith Deutsch, D., & Tyler Chowduri, N. (2009). *Introduction to special education: Making a difference.* Upper Saddle River, NJ: Pearson Education.

Sprafkin, J., Gadow, K. D., & Abelman, R. (1992). *Television and the exceptional child: A forgotten audience.* Hillsdale, NJ: Lawrence Erlbaum.

Spyri, J. (1899). *Heidi.* (H. B. Dole, Trans.). Boston, MA: Ginn and Company. (Originally published 1881)

Steinberg, S. (2006). Critical cultural studies research: Bricolage in action. In K. Tobin & J. Kincheloe (Eds.), *Doing educational research: A handbook* (pp. 117–138). Rotterdam, The Netherlands: Sense.

Steinberg, S. (2011). *Kinderculture: The corporate construction of childhood* (3rd ed.). Boulder, CO: Westview Press.

Steinberg, S. (2012). Redefining the notion of youth: Contextualizing the possible for transformative youth leadership. In S. Shields (Ed.), *Transformative leadership in education: Equitable change in an uncertain and complex world* (pp. 267–275). New York: Routledge.

Steinberg, S., & Cannella, G. (2012). *Critical qualitative research reader.* New York: Peter Lang.

Steinberg, S., & Kincheloe, J. (2004). *Kinderculture: The corporate construction of childhood* (2nd ed.). Boulder, CO: Westview Press.

Steinberg, S., & Macedo, D. (2007). *Media literacy: A reader.* New York: Peter Lang.

Stone, E. (1997). From the research notes of a foreign devil: Disability research in China. In C. Barnes & G. Mercer (Eds.), *Doing disability research* (pp. 207–227). Leeds: Disability Press.

Storey, J. (2001). *Cultural theory and popular culture: An introduction.* Essex, UK: Pearson.

Storey, J. (2003). *Cultural studies and the study of popular culture.* Atlanta, GA: University of Georgia Press.

Sullivan, M., & Lysaker, J. T. (1992). Between impotence and illusion: Adorno's art of theory and practice. *New German Critique, 57,* 87–122.

Swain, J., Finkelstein, V., French, S., & Oliver, M. (Eds.). (1993). *Disabling barriers, enabling environments.* London: Oxford University Press/Sage.

Talbot, M. (2007). *Media discourse: Representation and interaction.* Edinburgh, Scotland: Edinburgh University Press.

Thomas, C. (1999). *Female forms: Experiencing and understanding disability.* Buckingham, UK: Open University Press.

Thompson, J. B. (1981). *Critical hermeneutics: A study in the thought of Paul Ricoeur and Jurgen Habermas.* Cambridge, UK: Cambridge University Press.

Tobin, K., & Kincheloe, J. (2006). Doing educational research in a complex world. In K. Tobin & J. Kincheloe (Eds.), *Doing educational research: A handbook* (pp. 3–13). Rotterdam, The Netherlands: Sense.

Vygotsky, L. S. (1978). *Mind and society: The development of higher psychological processes.* Cambridge, MA: Harvard University Press.

Wallach Bologh, R. (1991). Learning from feminism: Social theory and intellectual vitality. In C. Lemert (Ed.), *Intellectuals and politics: Social theory in a changing world* (pp. 31–46). London: Sage.

Ware, L. (2005/2009). Many possible futures, many different directions: Merging critical special education and critical disability studies in education. In S. Gabel (Ed.), *Critical disability studies in education in education* (pp. 103–124). New York: Peter Lang.

Wasserman, D., Asch, A., Blustein, J., & Putnam, D. (2013). Disability: Definitions, models, experience. In N. Zalta (Ed.), *The Stanford encyclopedia of philosophy* (Fall). Retrieved from http://plato.stanford.edu/archives/fall2013/entries/disability/

Watson, J. L. (1997). McDonald's in Hong Kong: Consumerism, dietary change, and the rise of a children's culture. In D. M. Newman & J. O'Brien (Eds.), *Sociology: Exploring the architecture of everyday life readings* (8th ed., pp. 79–86). Thousand Oaks, CA: Pine Forge Press.

Watson, N. (2002). Well, I know this is going to sound very strange to you, but I do not see myself as a disabled person. *Disability and Society, 17*(5), 509–527.

Weber, M. (1991). *From Max Weber: Essays in sociology.* London: Routledge.

Weiner, B. (1992). *Human motivation: Metaphors, theories, and research.* Newbury Park, CA: Sage.

Wendell, S. (1996). *The rejected body: Feminist philosophical reflections on disability.* New York: Routledge.

Willis, J. W., Jost, M., & Nilakanta, R. (2007). *Foundations of qualitative research: Interpretive and critical approaches.* Thousand Oaks, CA: Sage.

World Health Organization. (n.d.). *Disability.* Retrieved from http://www.who.int/en/

Young, I. M. (1990). *Justice and the politics of difference.* Princeton, NJ: Princeton University Press.

Young, S. (2014, April). *Stella Young: I'm not your inspiration, thank you very much.* [Video file]. Retrieved from http://www.ted.com/talks/stella_young_i_m_not_your_inspiration_thank_you_very_much?language=en

Zalta, E. N. (Ed.). (n.d.). Philosophy. *Stanford encyclopedia of philosophy.* Retrieved from http://plato.stanford.edu/

Zeuli, J. (1986). *The use of the zone of proximal development in everyday and school contexts: A Vygotskian critique* (Occasional paper no. 100). Lansing, MI: Institute for Research on Teaching, Michigan State University.

Shirley R. Steinberg, *General Editor*

The Critical Qualitative Research series examines societal structures that oppress and exclude so that transformative actions can be generated. This transformed research is activist in orientation. Because the perspective accepts the notion that nothing is apolitical, research projects themselves are critically examined for power orientations, even as they are used to address curricular, educational, or societal issues.

This methodological work challenges modernist orientations and universalist impositions, asking critical questions like: Who/what is heard? Who/what is silenced? Who is privileged? Who is disqualified? How are forms of inclusion and exclusion being created? How are power relations constructed and managed? How do different forms of privilege and oppression intersect to affect educational, societal, and life possibilities for various individuals and groups?

We are particularly interested in manuscripts that offer critical examinations of curriculum, policy, public communities, and the ways in which language, discourse practices, and power relations prevent more just transformations.

For additional information about this series or for the submission of manuscripts, please contact:
 Shirley R. Steinberg | msgramsci@gmail.com

To order other books in this series, please contact our Customer Service Department:
 (800) 770-LANG (within the U.S.)
 (212) 647-7706 (outside the U.S.)
 (212) 647-7707 FAX

Or browse online by series:
 www.peterlang.com